ART TECHNIQUES FROM PENCIL TO PAINT

LIGHT & SHADE

ART TECHNIQUES FROM PENCIL TO PAINT

LIGHT & SHADE

PAUL TAGGART

Sterling Publishing Co., Inc.
New York

Library of Congress Cataloging-in-Publication Data Available

10 9 8 7 6 5 4 3 2 1

Published in 2003 by Sterling Publishing Co., Inc.

387 Park Avenue South

New York, NY 10016

First published in Great Britain in 2002 by TAJ Books Ltd.

27 Ferndown Gardens

Cobham, Surrey, KT11 2BH

©2002 by TAJ Books Ltd.

Distributed in Canada by Sterling Publishing

C/o Canadian Manda Group

One Atlantic Avenue, Suite 105

Toronto, Ontario, M6K 3E7, Canada

Sterling ISBN 1-4027-0225-6

CONTENTS

INTRODUCTION

Across the globe our ancestors used simple tools to create images of animal and human form on natural surfaces such as cave walls. The modelling of these forms was achieved through the manipulation of light and dark patterns produced with simple pigments, such as soot (carbon) from their fires. This was sprayed, stippled, or splattered across the surface in much the same way we apply strokes of graphite today.

In our drawings and paintings we need to shape space by controlling the effect of light, volume, and depth.

The logical starting point is working in monotone. This simply means working without color but using all of the shades of light and dark. Those starting on the road to painting are well served by learning to master the subtleties of monotone. There was a time when students at art colleges used to spend their first year drawing statues and plaster casts. They had to learn the importance of light and shade before they were allowed to embark on painting.

Leaping too soon into color often leads to confusion, for color, while being very seductive, cannot work on its own. Many paintings that fail do so because they lack a sufficient range of light and dark values.

To be able to take a step back and render the subject in monotone alone often reveals the problem. From the start, it is generally an advantage to draw out the subject in monotone before beginning on a painting. This is known as a "cartoon" in painting terms, and the production of these has a long history.

Begin your new venture with a little shading using line and tone. Once you feel confident, turn the shading into a simple color rendition. One color will do for the first attempt; then gradually expand your palette.

Keep the mixes simple, for it is usually simplicity that leads to the most stunning images.

Eventually, if your nature leads you to more vibrant colors, the line and tone shading can incorporate a rainbow of pigments.

By first dealing with values, you will have learned how to create volume. You will have discovered that light and shade is not simply a matter of light and shadow but is about learning to deal with all the middle values between black and white. Most importantly of all, you will have learned to assess the "value" of a color.

The value of a color is its degree of gray between the extremes of black and white. Take a bunch of flowers each with a different color. Photograph them first in color and you may well

be overwhelmed by their intensity. Translate this into a black and white photograph or photocopy and only their values remain. They will still have volume, however, and their differing values will suggest the variety of their color.

The interplay of light and shade over and around the bunch of flowers will not only bring out their volume but will also show their depth. In compositions, the greater the number of objects within, the more the depth requires organizing. By controling the depth in your image, you not only suggest space but also the focus.

All of this can be equally well achieved working purely in monotone or with the added dimension that color brings.

You will need to know about aerial perspective and how, through the control of value and color, you can invoke depth. What difference will soft or hard-edged strokes of color make to the depth or focus of a picture? How can it be applied to an open landscape? What part does it play in reflections in water?

One of the most important aspects you will need to understand is how to capture the effects of sunlight.

No matter how technically proficient you become in drawing and painting, without the effects of sunlight in your work it will always lack vitality.

Sunlight makes its way into portraits, still life compositions, flower paintings, and, of course, landscapes. It cannot be avoided. When you have it in your grasp, you will make a giant leap forward in your work, which will make all your hard won efforts to that point so worthwhile.

A great many of our ideas start at the point of a pencil, for it is here that we begin to reflect and model our environment.

The pencil is one of our most common, yet versatile tools. With it you will begin to create the illusion of light and shade using a range of pure tones or grays.

Pencil will always be one of the strongest tools at your disposal, and it will prepare you in so many ways for any potential hurdles in the other media that you wish to explore. Spend time working with pencils and develop your confidence in using them. By building a strong foundation at this stage you will recognize the natural progression from drawing into painting. A journey that also involves developing an intimate knowledge on the subtleties of light and shade.

There are many other media in which light can be depicted in monotone, so carry the confidence you have built with pencil into these first.

While color can be introduced before you leave the world of dry media, it makes such an impact on your work that it is best to introduce it gently. Always remember the most powerful element of any color mix is its value (how light or dark it is against other colors in the image) rather than its overall strength.

The swiftest way to apply color is with a brush, and having explored color in dry media, you can move on to the techniques of applying paint to successfully manipulate light and shade.

Every medium has advantages and disadvantages. To assess one against the other takes time because you have to become intimate with the properties of each.

This is exciting and rewarding, but it does require patience; for without patiently trying things out for yourself, you could become frustrated.

Stretch the possibilities offered in the subjects featured by not only rendering them as shown in the exercises, but by also trying the same subject in different media, for there is a distinct advantage to working in this way. Drawing a study or composition in pencil will not only help you understand the values required in the paint, but will also give you something to compare the painted version against as well as helping you assess the properties of each medium.

Exploit this book to the full, as it represents one of the most satisfying areas of drawing and painting. Once mastered, you will be able to achieve depth and light with the manipulation of light and shade in all manner of media.

MATERIALS

To better understand the effects of light and shade on a composition, there is nothing to compare with painting outdoors. Sadly, however, many painters do not venture out of their studio simply because the prospect of choosing which materials to take presents a daunting prospect.

I am often asked which media is the best to work in outdoors. The answer depends on the circumstances in which you are going to paint, rather than the suitability of any particular media to do the job well.

If there is a problem with transporting the materials, then you will need something that ideally fits in your pocket or a small bag. However, should working at speed be the criteria, the answer could well be watercolor paints for fast, fluid coverage. Oils on the other hand will stand up better to bad weather, for if you don't mind getting a little damp neither will they. Pastels are a joy to use outdoors since you no longer have to contend with the dust and can keep the kit of materials down to something quite basic. Fast drying acrylic paints are

perfect and can be brought into play in thin form (using watercolor painting techniques) or thicker (using oil painting techniques), though their very nature can, on occasion, require the use of agents to slow down the speed of drying.

To determine what you could take, ask yourself the following questions:

Am I restricted by what I can carry?

What am I setting out to do? Is it gathering reference material and sketches to work up back at home or producing a finished painting?

Sketching

You should always have a basic pencil sketching kit at hand with which to record ideas, for you could miss that "once in a lifetime" experience that may have provided the perfect subject. I store mine in a flat tin box, which is kept with a sketchbook. To add to the experience of dry sketching, add a few other "natural" color leads, such as sanguine, brown, or sepia; or better still, branch out further to include some colored pencils.

BASIC DRY SKETCHING KIT
2B Pencil
2B Graphite Stick
2B Flat Sketching Pencil
Black Charcoal Pencil
Kneadable Putty Eraser
Spiral or Casebound
Heavyweight Cartridge Paper
Sketchbook

If working in watercolors is out of the question but you still wish to produce sketches with the qualities of line and wash, a set of watercolor pencils, plus one round watercolor, brush is the answer. It is important to have a long lead on a watercolor pencil. Don't sharpen it with a pencil sharpener. Pare away the wood from the lead and finish off by sharpening the tip of lead only. HINT: Sharpen over a receptacle and keep crumbs to use in work.

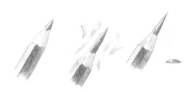

BASIC WET SKETCHING KIT
2B Pencil
Black Chinagraph Pencil (wax pencil that will not dissolve in water)
Tin of Artist's Quality Watercolor Pencils
Round Nylon Watercolor Brush (Large No. 10)
Kneadable Putty Eraser
Spiral or Casebound
Watercolor Paper Sketchbook

Watercolors

Being light and easy to clean, watercolor materials make excellent travelling companions when going abroad or out and about.

SURFACES

Drawing boards can be a little cumbersome. Do you pack them or carry them under your arm? On arriving at your destination you are then faced with having to fix the paper to the board by either pinning or stretching it. This takes time and can be inconvenient, especially when the stretched paper has to be left somewhere flat to dry. A Watercolor Block is the useful alternative. These come in a variety of sizes and will work well for sketching and producing finished paintings.

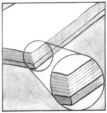

Even the largest watercolor block is easy to carry. No need to take a drawing board on which to stretch paper.

Sheets of watercolor paper glued along all edges — except one small section. Produce painting on top sheet of block. Do not remove top sheet until painting is complete.

Once painting is completed, slip blunt knife into unglued section. Run along all edges and gently lift off. Take care not to pull away other sheets beneath.

PAINTS AND PALETTE

For complete paintings it is best by far to carry a basic selection of tube colors. Whether working in the studio or out and about, I stick to my basic color palette from which most of the colors that I am likely to need can be mixed. This comprises of the three primary sets with two colors for each, one of which has a warm bias, and the other a cool bias, so that the secondaries can be cleanly mixed: Yellow-green (Lemon Yellow), Yellow-orange (Cadmium Yellow), Red-orange (Cadmium Red), Red-purple (Alizarin Red), Blue-purple (Ultramarine), Blue-green (Prussian Blue). For bright blue skies there is one color that I find invaluable and it is Phthalocyanine Blue, most commonly referred to as Phthalo Blue. When working with tube colors a large flat plastic palette is best, featuring wells in which to squeeze quantities of the paint and a flat area on which to mix washes. Especially useful are those with a thumbhole, as this allows you to also grip several brushes while working.

For sketching with watercolors or in cases where you are restricted by the amount of materials that can be carried, a traveling box is the answer. Most have an additional integral palette while some also feature a retractable brush. These can be customized to hold your preferred range of colors as the blocks (half pans) of paint are removable.

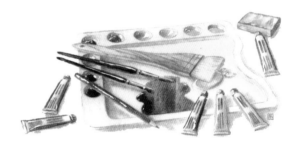

BASIC WATERCOLOR KIT

2B Pencil • Kneadable Putty Eraser • 6 Tubes of Paint or Traveling Watercolor Paintbox • 1 Large Plastic Palette (if using tube paints)
1 Large Round Nylon/Sable Watercolor Brush (No. 10 or No. 12) • Surface (Watercolor Paper Block)
2 Receptacles for Holding Water (1 for cleaning brushes : 1 for clean water to be added to mixes) • Absorbent Tissue

OPTIONAL EXTRAS

Masking Fluid • Hake Brush (for wetting surface & large paint washes)
Blending/Retarding Medium (to slow rate of drying in hot climates) • Portable Easel

Oils

Working with oil paints outdoors need not be as problematic as some might think, and the joy of working alla prima, completing a painting in one day, is something that every painter should experience.

It is a nuisance attempting to transport an oil painting kit when traveling on airlines since regulations prohibit passengers from traveling with any solvents. I therefore advise painters to either substitute traditional oil paints with the water-soluble variety or to work in acrylics rather than nothing at all.

PAINTS & PALETTE

Again, as with watercolors, I stick to my basic color palette from which most of the colors that I am likely to need can be mixed. This comprises of the three primaries with two of each color; one of which has a warm bias, and the other a cool bias, so that the secondaries can be cleanly mixed: Yellow-green (Lemon Yellow), Yellow-orange (Cadmium Yellow), Red-orange (Cadmium Red), Red-purple (Alizarin Red), Blue-purple (Ultramarine), Blue-green (Prussian Blue). Other than these and the optional Phthalo Blue, a Titanium white is required for

adding to paint mixes. A nonabsorbent (non metallic) palette is a necessity, featuring a thumbhole that enables you to grip several brushes while working.

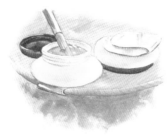

DIPPERS

These clip onto the edge of your palette and hold small amounts of medium. When filled to the brim, paint-soiled brushes can be dipped into the contents without touching the bottom, thus avoiding the possibility of depositing unwanted color. Dippers with caps are essential to transport the medium and keep out air between use, to prevent the medium from drying out. While dippers are available in plastic, the sturdier versions are metal with brass caps (to prevent rusting).

BASIC OIL PAINTING KIT
6 Tubes of Paint plus Titanium White
1 Nonabsorbent Palette (nonmetal)
1 Large Round Bristle Brush
(No. 10 or No. 12)
1 Medium Round Bristle Brush
(No. 6 or No. 8)
1 Small Round Bristle Brush
(No. 3 or No. 4)
Surface (Canvas Board or Oil Paper)
2 Dippers (1 containing medium and
1 for Artists' Distilled Turpentine)
Jar of Turpentine Substitute (for
cleaning brushes)
Small Jar Drying Gel Medium
Lint-free Rag
Portable Easel

Accesories

PROTECTING BRUSHES

Carrying brushes can cause damage, however robust they may appear. It makes sense to protect these essential tools, and there are propriety products designed specifically for the job, from rolls to tubes. Alternatively, you can make your own from a split bamboo/rush tablemat, a length of thin elastic, and some thin shoelaces. Ensure brush heads face upward or in a direction that allows them to breathe and dry out. Ensure tips do not protrude above rim of roll in order to prevent damage.

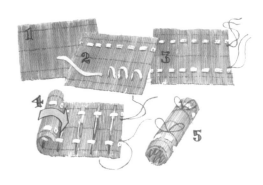

1 & 2. Thread lengths of elastic through gaps between split rush/bamboo and knot at both ends to secure.
3. Thread laces through one end and knot at base to secure.
4. Slot brushes in place and roll.
5. Wrap laces around roll and tie with bows.

Easels

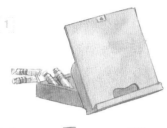

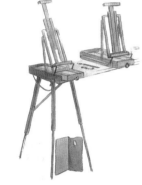

For your own comfort, an easel is an essential piece of equipment when painting outdoors. With an easel your work can be at your eye level so that all you simply have to do is glance from surface to object rather than bend over to work. It is worth investing in a portable easel that doubles up as a carrier for your materials and for your wet painting.

1. The hinged carrying easel is designed to transport and store materials inside the box. The lid features a lip and hinges open at different angles, to act as the support for your painting surface. It can be used either as a lap/surface easel or in the home as a table easel.

2. The portable box easel is somewhat more sophisticated with retractable legs so that it can be used at different heights. With the legs folded away completely, it can be used as a table easel. The sliding inner tray is metal lined with a hinged removable wooden lid that folds out to double up as an oil painters palette. The support can be angled and when folded away tucks neatly onto the lid of the tray.

3. Leather shoulder straps complete the picture so that it can be carried on the back, with the painting held in place for ease of transport.

Pastels

While a pastel painting can be produced outdoors, the range of colors and tints required mean that you will need a fairly extensive set. This could become unwieldy, and it may suit you best to use a limited pastel kit to produce rapid sketches. Experiment with various types of pastels such as hard square sketching pastels, soft pastels, and wax crayons.

BASIC SKETCHING PASTEL KIT
Box of Sketching Pastels
Erasing Knife (for scratching through and correcting mistakes)
Compressed Paper Stub/Stump (for blending)
Kneadable Putty Eraser
Tinted Pastel Paper
Sketch Pad

BASIC WAX CRAYON KIT
Box of Wax Crayons
Erasing Knife (for scratching through and correcting mistakes)
Artists Distilled Turpentine (for blending)
Round Watercolor Brush (for blending turpentine)
Oil Paper or Canvas Board Offcuts

COLOR MIXING

One's first steps into color mixing are often dogged by the appearance of dull gray mixes. Problems loom. For instance, why is it that when black is added to a shadow (seemingly the obvious thing to do) it sometimes turns green instead? Frustration soon sets in hereafter.

The simple fact is you cannot keep all your colors bright, because if you do your paintings will dazzle the eye and there will be no balance or harmony, no softness, and no subtlety.

Somewhere along the line you must eventually face up to the fact that you have to master grays. But don't despair. By learning to mix grays you will have forged the final link in your understanding of color mixing. In a short space of time not only will you be able to mix a range of unique grays but you will also be able to use them to make your bright colors shine out in contrast against them, the very essence of achieving light and shade in your painting.

Basics of Color Mixing

PRIMARY & SECONDARY COLORS

The colors around the outside of the color circle are all bright and are known as hues. They are composed of the three primaries: red, blue, and yellow. These three primaries mix to form secondary colors: orange, green, and purple. Each primary has a warm or cool bias, moving from either side of the middle, toward its secondary mix. Therefore, red goes from red-orange [Ro] (warm) to red-purple [Rp] (cool). Blue goes from blue-purple [Bp] (warm) to blue-green [Bg] (cool). Yellow from yellow-orange [Yo] (warm) to yellow-green [Yg] (cool).

COMPLEMENTARY COLORS

Colors that appear exactly opposite each other on the color circle are known as complementary colors. Mix the right quantities of any primary with its opposite secondary and each will neutralize the other, resulting in a dull, dark color (theoretically black, otherwise known as a colored gray). For instance, some reds are orange, while others are purple, thus their true opposite will reflect this, moving from blue-green to yellow-green. When looking at a color, therefore, you must ask yourself two questions before you can find it's complementary. What is its hue (i.e. red) and what is its bias (i.e. purple)? From this you arrive at the conclusion that the primary is a red-purple. The opposite of a red-purple is a yellow-green.

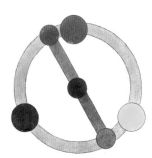

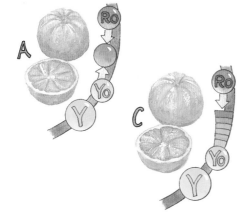

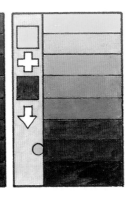

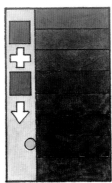

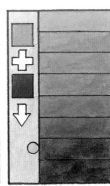

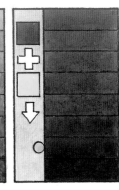

LIGHT

To keep secondary mixes bright, colors with the same bias must be used in the mix. For example, a bright secondary orange is achieved through mixing the orange bias Cadmium Yellow [Yo] and Cadmium Red [Ro]. To mix a bright secondary green, bring together the green bias Lemon Yellow [Yg] and Prussian Blue [Bg]. The gradation of the yellow can be varied as the second primary is added to create a range of bright colors that can be effectively exploited.

SHADE

Before a color is totally neutralized to a gray by its complementary, it goes through a succession of decreasing intensities. On the way to gray, or even when a gray mix goes wrong, a succession of subtle colors are achieved that can be glorious to use. By taking just one segment of the color circle and using the complementary blue to orange mix, you can attain a tremendous variety of intensity, temperature, and value, while still remaining within a small family of colors.

TERMS ESSENTIAL TO UNDERSTANDING COLOR MIXING

HUES

Bright primary and secondary colors are known as hues.

VALUE

Some hues are very light, while others are dark = different values.

INTENSITY/CHROMA

Dull colors have a lower intensity than the bright ones.

TONE

The degree of lightness or darkness of a neutral gray.

COLOR MIXING

Where the prefix letter is shown in capitals this denotes a larger quantity of that particular color.

Conversely, where the prefix letter is shown in a lower case, this denotes a smaller quantity of that particular color.

E.G.

Bp = large amount of blue-purple.

bp = small amount of blue-purple.

COLOR REFERENCE

Red-purple (Rp) • Red-orange (Ro)

Blue-purple (Bp) • Blue-green (Bg)

Yellow-orange (Yo) • Yellow-green (Yg)

Grays

WHAT IS A GRAY?

White light contains all the colors of the spectrum. A perfect gray or black would be a pigment that could absorb all of the color from white light.

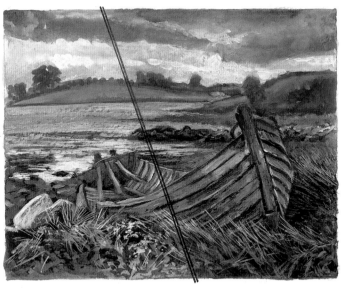

Pigments eat colored light and thus the pigment that we call red actually swallows green light, and the resultant reflected red light is what our eyes pick up.

Conversely, green actually eats red light, reflecting the green that we see.

USING GRAY

Using a range of values in one gray only allows you to work out the balance of light and shadow in your painting. This technique of Chiaroscuro was employed by several of the old masters often as an underpainting, subsequently glazed with color.

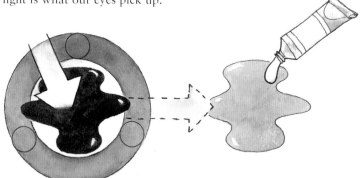

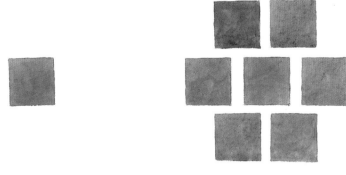

A combination of two such colors, exact opposites on the color circle, will absorb all the color from "white light." These are the complementaries. This new black pigment can be lightened in value by the addition of white (oils) or water (watercolors) to create a gray.

Different primary and secondary complementary mixes provide a variety of grays. A gray can be deceptive for it is only when placed beside other grays that you can see its true nature. The box on the left seems merely to be a gray. However, place it among others and you can see it is a quite distinctive gray with its unique characteristic. Now try to identify the complementaries from which each of the others is composed.

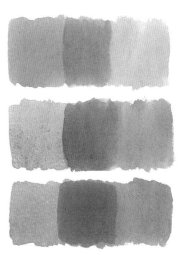

Warm or cool dull colors overlaid in transparent washes create "visual" grays for the rendition of white objects.

By increasing your range of grays in this way you are extending your color palette, giving you additional subtle colors for your painting. This study was completed using only a palette of mixed colored-grays.

These can be separated into warm and cool grays.

Whites

WHAT IS WHITE?

We all take white for granted, that is until we start to paint! It is crucial that you look closely at the color of white to discover its true identity, and to do so you need to learn to compare whites.

UNDERSTANDING WHITE

Find as many pieces of white paper as you can around your home, such as newspaper, a piece of typing or writing paper, a sheet of toilet paper, or a tissue. Lay them next to each other on a table and compare their whiteness. Even though you know that they are all white, some may now look slightly pink, or blue, or yellow and so on. This is their local color, the natural color under normal daylight conditions and as becomes obvious, each actually has a subtle coloration.

Take an object that has a bright color, for instance a flower, a plastic spoon, or a printed carton. Bring the object close to each white surface in turn. Note how this color is reflected onto the white. The stronger the light hitting the object, the stronger the reflected color will be on the white.

Take a strip of white paper and place it across two colored backgrounds. Does the white remain the same?

Fold each piece of white paper in half and stand it upright. One of the folded surfaces will now be lighter than the other. Try to determine the difference in the color.

Hold the strip partly against the sky and partly against a dark background. Does its lightness or darkness seem to vary against either?

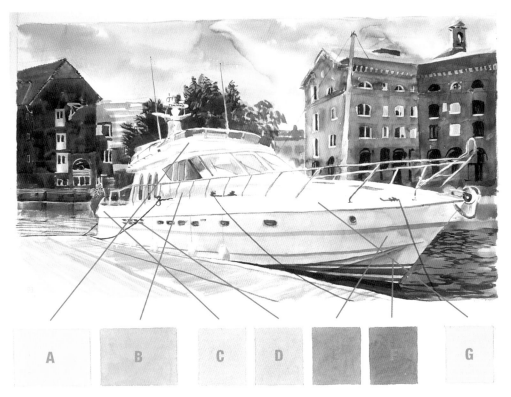

| A | B | C | D | E | F | G |

USING WHITE

Mixing any two complementaries that appear exactly opposite each other on the color circle gives us a near black/colored gray, which is never completely neutral but has a slight bias toward one of the colors from which it is composed. Such colored grays can now be taken and made lighter in value by the addition of water (watercolor painting) or white pigment (oil painting) to produce the subtle colors that you will need to capture the whites of nature. Each has a bias of color that can be any one in the color circle. They can be lightened or darkened by contrasting with other colors within your painting.

Having discovered the many ways to analyze the colors of white, you must compare the white in question to another white nearby to understand its nature. As soon as you do, you will see if it is lighter or darker, warmer or cooler, or brighter or duller than its neighbor. Observe carefully the colors used to paint the white yacht.

[A,B] If the color were to be extracted from an area that is well lit by the sky and compared to an area in shadow, you could immediately see the difference. The well-lit area features a warm yellow-orange [Yo] while the shadow area a cool dull green [Bg+yo].

[C-F] However, within an area of shadow the bias of a color can change. Taking the shadow area down the side of the boat we can extract the colors and see that they can be slightly blue, yellow, purple, or green.

[G] Nevertheless, the whole area is generally darker than the well-lit deck above.

21

Greens

SECONDARY MIXING TO ACHIEVE GREEN

In pigment, a secondary color is created from the combination of two primary colors. Thus, when blue and yellow are mixed a green is produced. As with all things, the reality is a little more complex, which far from being a problem offers the artist a greater range of choice and possibility. Let us first look at the results of mixing yellow with blue.

The first possibility is to create bright greens by mixing two cool colors. Prussian Blue (Bg) and Lemon Yellow (Yg) have a definite bias toward green, and both are considered cool against their warmer partners Ultramarine (Bp) and Cadmium Yellow (Yo), which have a bias away from green.

This first simple range of hues should not be underestimated, for it provides the artist with the means of creating sunlight and shade across the most frequent colors of our landscape. The light from our sun is not white but yellow, and shadow is thus cast in complementary blues and purples. Masters of their color palette, the Impressionists were among many to exploit this truth.

Once this base line of colors is established, they can then be lightened to change their value. In watercolor painting this is achieved through adding water; while working with an opaque medium, such as oil, requires the addition of white, which has a tendency to dull the color.

Darkening a color's value is simply achieved by adding less water (or less white) or more pigment, depending on the prevailing mix.

NOTE

1. The biggest value change when thinning a color is in the mixes with predominantly blue in their composition. This is entirely due to the fact that blue is naturally a darker value than yellow. So the more a mix contains, the darker it will be (vertical columns).

2. The lightest color band (bottom line of top diagram) best describes the variation in hue, as the value change is at a minimum.

3. The darkest color band at the bottom of the bottom diagram describes both a change of hue and value.

4. In a transparent medium, such as watercolor, the depth of a pool of applied color on the painting surface will affect the pigment density of the area once the paint is dry. Thus, a color can be often altered during painting by either loading such a pool to darken resultant color or wiping the brush on a tissue to reduce the thickness of a paint layer being applied, thus lightening it.

SHADES OF GREEN

Adding black to a color creates a shade. Shades have their uses, but black can dull color very swiftly. For winter landscapes and the like, however, this quality can be exploited in a positive way.

TINTS OF GREEN

Adding white to a color creates a tint. This, however, creates an opaque or semiopaque paint. In watercolor this is best used against a colored ground (here a pastel paper). Chinese White is the traditional white of watercolor, as it is the most transparent white available. In oil its place is taken by Zinc White. For more opacity use Titanium White in both media. Tints can be used in thin washes over previously laid color to lighten, soften, and recede.

Blues

COLOR TEMPERATURE

Blue is generally regarded as a "cool" color, being associated with cool objects or environments, such as water or ice. However, within the range of tube colors available there are blues that have a tendency toward either purple or green. Those with a bias toward purple can be seen as "warm" and those with a bias toward green as "cool". Often when using blues in a landscape, the color temperature can differ, for example a warm blue sky reflected in water can become cool or vice versa.

VALUES

Straight from the tube, blue is usually a dark color, which is lightened by adding water (watercolors) or white (oils). This change of value alone can be sufficient to create volume, space, and light. Note that by adding white to blue, the blue will tend to dull down somewhat. You must balance the benefits of value and contrast, against the necessity for intense color in whatever you are painting. On the left you can see that all values of the blue are intense, but carefully judge the middle values for intensity against those in the example on the right where white has been used.

DISTANCE

As warm colors appear closer than cool, a simple variation of color temperature can be exploited to suggest recession or aerial perspective. The central hill in this exercise is a mix of BP + Bg and as such is not as intense as the other two, demonstrating that colors will always dull when mixed — even when the mix is a simple one such as this.

RECESSION

A sense of distance or "aerial perspective" can be achieved simply by reducing values in depth. Here a secondary mix of Bp+Rp exploits purple values.

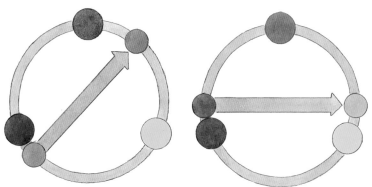

COMPLEMENTARY CONTRASTS TO BLUE

By mixing blue with its opposite or complementary orange, a neutral color, or gray, can be created. Since there is a choice of blues, there must also be a choice of opposites. So which to use? The first color circle shows the true complementary to Bg and in the second circle that to Bp. By choosing and mixing with the correctly positioned complementary, a perfect neutral gray is produced.

RECESSION

Distance leeches the intensity from color. By gradually graying a color with the addition of it's complementary, "aerial perspective" can be suggested once more.

NOTE: Since blue is associated in our minds with distance, a color moving toward blue seems to move away from us, providing the final tool in your repertoire to suggest recession.

Yellows

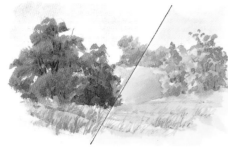

LIGHT

Yellow is a warm color that we associate with summer and sunlight. On a dull day, when the yellow light does not reach the landscape, all the colors tend toward blue and feel very cool. By adding yellow to the mixes the sunshine returns and we begin to feel its warmth across the land. Be bold with the amount of yellow you place in mixtures for such highlights. This is the secret of sunshine without which your painting may look very sorry and cold. No matter how much tonal contrast you create or how well painted the detail, sunlight will elude you until the yellows are exploited.

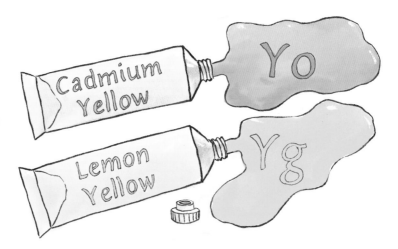

Yellow can have a warm or cool bias. Cadmium, Indian, gamboges, or chrome yellow are warm yellows because they lean toward red, being a very orange yellow (Yo). Alternatively, zinc or lemon yellow can be cool and lean toward green (Yg).

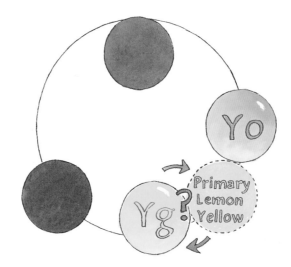

The cool bias is always more subtle and in some yellows almost imperceptible (Zinc Yellow for example). You can easily treat these "lemon" yellows as being true primaries without a natural bias. For the purposes of clarity, it is useful to term them all yellow-green (Yg), which defines their position on the color circle and differentiates them from yellow-orange (Yo).

Volume & Shadow

ADDING BLACK

Adding black would seem the most natural method to create a shadow color. Unfortunately, black is seldom as neutral as it appears in raw form. Black is in fact a colored gray, or more simply put, a very dark, dull color, and adding it to a color creates a shade. More often than not, the addition of black to yellow creates an olive green, rather than a dark yellow. Rather than reject the mix out of hand, accept it as a way of achieving a subtle green.

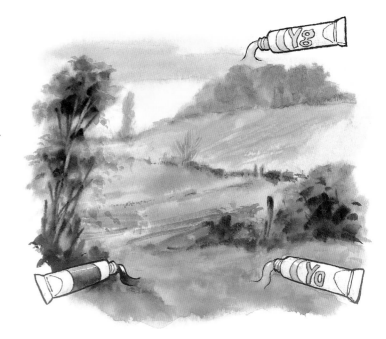

ADDING A COMPLEMENTARY

With objects whose local or natural color is yellow, a way of dulling and darkening the color to create volume and shadow is required. This is achieved through using the yellow's complementary to dull or darken, or both together. By understanding this process and the principles behind this color mix, you will not only gain control over the yellow mixes but also will vastly extend your repertoire of colors. Complementary colors are those that appear directly opposite one another on the color circle. The complementary of Primary Yellow is purple. If the yellow is warm, biased toward the red, as with Cadmium Yellow (Yo), its true opposite will be slightly bluer. Should the yellow be cool, biased toward the green, as with Lemon Yellow (Yg), its true opposite will be slightly redder. By gradually adding the correct complementary purple to yellow, the color will become darker and duller until it reaches such a level as to be considered black.

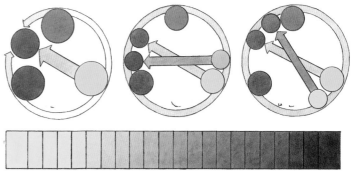

Introduction

Are you confused when trying to conclude what is meant by the terms shadow, shade, tone, and value, all of which appear to describe the same thing? Rest assured that you are not alone, for when starting to explore the matter of light and shade, there are very few who are not. These various terms exist as a means of pinning down our understanding of what is meant when talking about the dark area of an object.

The term "shadow" would seem obvious, but that often leads to the first mistake when starting to draw or paint them. The perception of a shadow is that it is dark; consequently, the temptation is to reach for a tube of black paint. This, unfortunately, would not do, for black pigment not only immediately dulls color, it also makes it look dirty.

Shadows can be luminous or intense in color while still being dark. Far from being a different color, a shadow is visually a dark version of the object's color when it is in the light. In other words, the color of a shadow on a blue ball in normal light is a dark blue, as opposed to black. We need to control our color mix to take this into account.

On the other hand, shades are color mixes that have black added to them. Some shades can be interesting; for example, olive green is a shade of yellow, which is useful for dull foliage.

Values and tones probably cause the most difficulty. The term "value" is often referred to in a dictionary as a "tone" and vice versa. However, values are in fact the degree of darkness of a color. For instance, blue is dark in value while yellow is light. If you were to take a black and white photograph of a number of colored squares, what you would see would be a series of gray squares. These would represent the values of the colors.

On the other hand if you were to paint a series of gray squares in their own right, these grays would all represent separate tones. Tones, therefore, are the degree of darkness of a gray.

All of these terms are misused in general parlance, but to know their exact meaning is helpful when it comes to drawing and painting. Each plays their part in creating light and shade, and to know the process by which they are created and changed is important.

In the past, art students spent their first year learning about tones, for it was considered that the manipulation of space in black and white had to be understood before one could move on to color. Although this may seem slightly arcane in this day and age of color saturation, this was a vital point. For tone can exist without color, but it is less easy to deal with color and ignore its value.

Even when mixing a color, the most important element is its value. If this is correctly gauged, even if the hue (original color) were wrong, you would probably get away with using the resultant mix. Working with tones first enables you to become more skilled in assessing the value in any color, and this is one of the most important lessons that any painter must learn.

This section deals with media that can create light and shade working only in black and white. The various media can be used to make studies that will help you assess the values within color or to create monochromatic images. The choice is yours, but never underestimate the worth of working without color.

MATERIALS
Graphite Stick • Graphite Pencil • Charcoal Pencils - Soft, Medium, Hard
Charcoal Sticks • Charcoal Crayons • Chinagraph
Correction Markers • Kneadable Putty Eraser
Paper Wiper • Smooth Cartridge Paper

Always sharpen point of graphite stick with sharpener. Save shavings in tin. Special sharpeners store graphite automatically.

Warm kneadable putty eraser in palm of hand and mold into chisel shape.

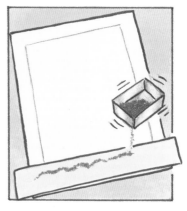

Draw rectangle on smooth cartridge paper. Drop graphite shavings onto paper strip butted up to one edge of rectangle.

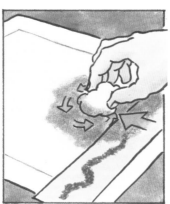

Use cotton wool ball to spread graphite toward center.

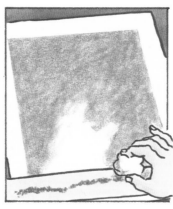

Repeat on each of four edges until rectangle is covered with graphite shading.

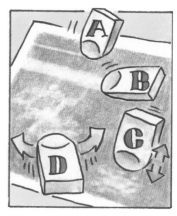

Use molded kneadable putty eraser to lift off graphite using various strokes.
[A] line [B] mass
[C] dabbing (texture)
[D] rolling (texture).

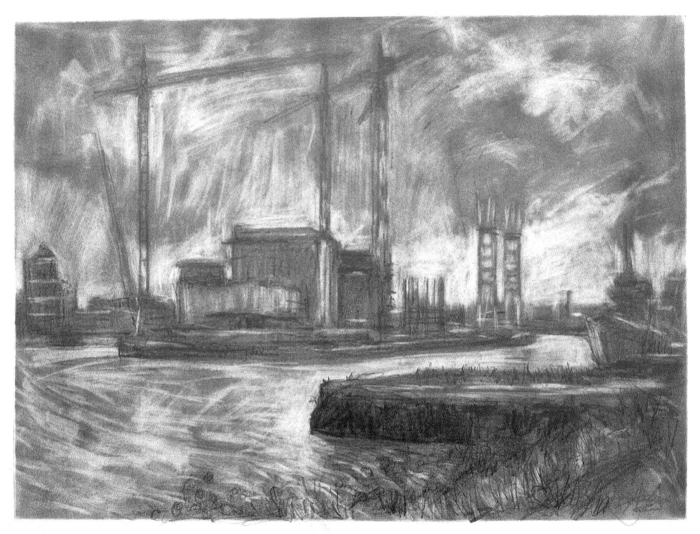

Graphite Stick

Once you have discovered the wonderful properties of a graphite stick, one will never be far from your hand. It is most important to keep the point sharp, not for its point but for the fact that the chamfered side of its point is perfect for blocking on large strokes of graphite. This speeds up pencil drawing incredibly, but it does mean that you will inevitably create a lot of graphite dust and shavings. Keep these shavings in a tin, but make sure that any plastic coating does not contaminate the graphite shavings. This loose graphite is invaluable as a drawing tool in its own right, as can be seen in this example of an on-the-spot sketch of The Lowry building during construction in Manchester, England. The initial drawing was blocked in using a graphite stick on the surface that had been prepared in the studio before going out. This was worked in with a paper wiper. Once the initial shapes were established, a kneadable putty eraser was used to discover the lights. This was done freehand, rather than grappling with stencils on what was a fairly blustery day. Several showers interrupted the work, as a couple of dark streaks in the sky will attest! These were caused by the use of the putty eraser over random raindrops that fell on the work.

Start drawing using hard density charcoal pencil. Strengthen line with stick charcoal. Block tone with charcoal crayon.

Blend charcoal into surface with paper wiper. Resharpen image with medium density charcoal pencil.

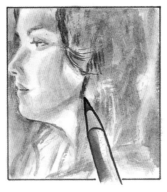

Restore highlights with kneadable putty eraser.

Dense linework and texture for final accents achieved with soft charcoal pencil.

Charcoal

Charcoal is one of the most responsive mediums you have at your disposal. It is so light on the surface that even overenthusiastic fixing can cause it to move across the surface. Since it comes off so easily, why not use this to your advantage not only for the correction of mistakes but also for returning light and highlights to previously laid areas of tone? The density of the black carbon and its softness go hand in hand for rich shadows, and thus it is an excellent medium in which to capture the effects of light and shade. In this study of a woman's head we have the full range of tones available. To achieve these, a combination of charcoal tools needs to be brought into play. The initial drawing, which needs to be light and loose, yet definitive, is made using a hard charcoal pencil. This gentle line will disappear entirely under the heavier strokes that follow, but use a kneadable putty eraser to refine the shapes until they are correctly aligned and proportioned. Stronger lines — worked with a charcoal stick — along with smoothly blocked areas of tone — achieved with a medium charcoal crayon — provide the strength one would expect of this medium. This is softened and smeared over the surface with a paper wiper. Two more layers of charcoal pencil follow, using increasingly softer degrees, medium and soft, are interspersed with highlights retrieved using a kneadable putty eraser. The finished result is simple and swift and provides a study that supports all the tones that are needed to suggest light and depth. Charcoal is always best when worked on a slightly larger scale, which allows broad gestural strokes and a loose approach. Use a surface that is relatively smooth, or its texture may predominate. If it does, then you must incorporate its characteristics into the finished piece.

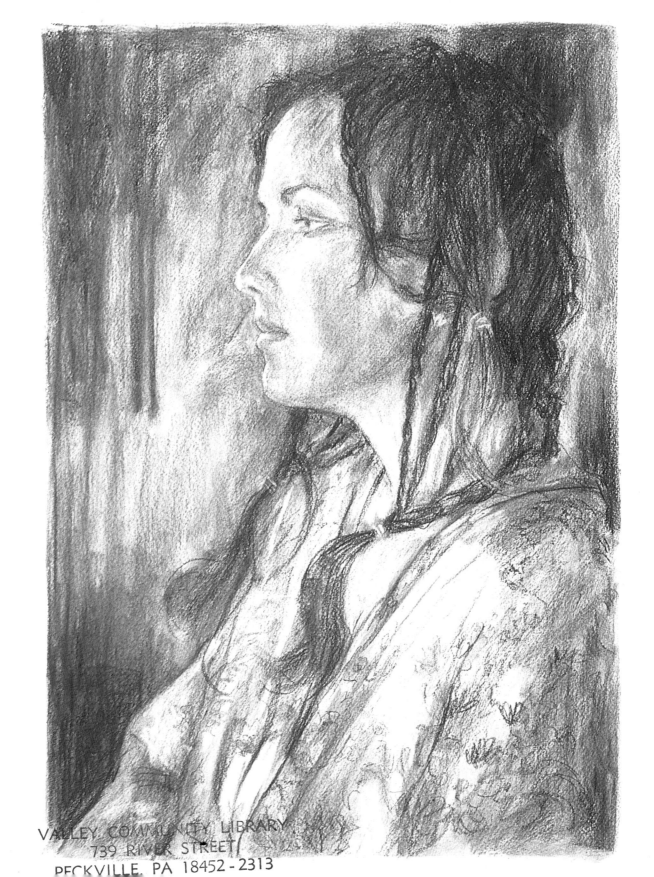

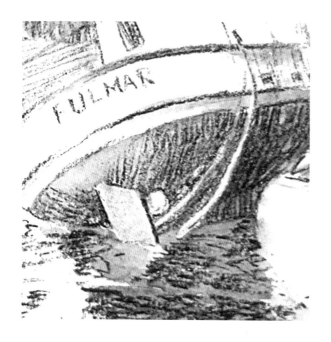

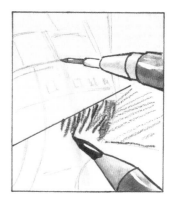

Because point of chinagraph pencil wears down, revolve continually as you work to sharpen.

Any initial work sketched in graphite pencil (top) can be completed in chinagraph (bottom).

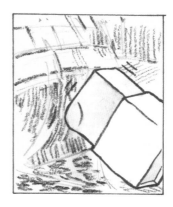

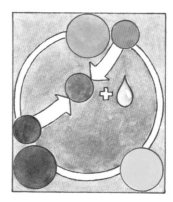

Gentle erasure with kneadable putty eraser removes pencil, leaving chinagraph marks.

Monochrome color mix: Orange (Ro+Yo) plus blue (Bp) creates dull brown (colored gray).

Chinagraph

Chinagraph is a waxy pencil whose line will repel water-based media, such as watercolor and ink. This makes it an excellent candidate for line and wash, as the line is difficult to overwhelm. Its line is also a very dense black, which makes it a superb foil for either gray tones or color. Once the drawing is established with the chinagraph pencil, tones can be added with great freedom using watercolor, ink, or very fluid acrylic paint. In this example, the medium is watercolor and a good amount of a very dull brown was mixed, using complementaries. You could use a premixed brown, but mixing your own is good practice and creates a color unique to this occasion. Paint can then be extracted from the edge of the mix as required and thinned with varying amounts of water. A mixed brown, such as this, presents another unique characteristic in that the color can tend to separate, especially when applied in fluid washes. This is known as granulation and is evident in the sky. Overpainting the image using the Wet on Dry technique affords you a choice of approaches. You could mix a different solution for each area, some light and some dark. Alternatively, you could use the same thickness of color, but build up layers, allowing each to dry, before applying the next. Whichever method you choose, you will have managed to control the light and shade as tonal washes without the use of color. One further approach: If these tonal washes were produced using waterproof ink or acrylic, they would be permanent, and a layer of color — in ink, watercolor, or acrylic — could be added to complete the picture.

Graphite Stick & Correction Marker

With a graphite stick in your pocket, you are ready to sketch anywhere and at any time. A log store outside the barn in the rural hills of Tuscany provides the inspiration for this graphite sketch. Graphite in pencil or stick form is bound together in a wax base, which begins to flow when dissolved with a thinner. An extremely convenient way to have thinner at hand is in the form of a colorless marker, known as a correction marker. Available from office supply stores, these are used for correcting or dissolving previously laid marker strokes made on acetate sheets for overhead projectors. When used in this manner with a chinagraph, they dissolve and push the graphite across the paper surface. This graphite also finds its way downward, into the paper fibers, which renders it less easy to erase and is another technique in its own right waiting to be explored.

Step 1

Look at the variety of marks that are possible with just one 2B Graphite Stick. Different pressures and varied direction of stroke really make an exciting and speedy start to the drawing. Much of the surface is covered, and the composition is established. A scrap piece of paper can be used as a simple mask for sharp edges such as the roof edge.

MATERIALS

Graphite Stick

Correction Markers

Artists' Quality Heavy
Cartridge Paper

Step 2

For more detail and finer line and strokes, a 2B pencil may be brought into play. The shading is still achieved through hatching, but again, look at the variety of marks achieved with just one drawing tool. Let your imagination really go at this stage to see how many textures can be created while building up the tones.

Areas to investigate more closely:
[1] Some of the spaces are now filled between the circular logs.
[2] The really loose build up of the grass in the foreground
[3] By using the point of the pencil held flat to the surface, the lines around the stones of the wall become soft and very descriptive.

Step 3

This is the point at which the correction marker comes into play. Note how dense the graphite can become and how pencil lines and strokes are softened when dissolved with the marker. The felt tip of the marker may need frequent cleaning on a tissue, or you may exploit the fact that it collects some graphite and use it almost like a paintbrush on lighter areas. Try to be as varied with the strokes of the marker as you were when working with the graphite stick and pencil. While graphite is not being added at this stage, blending and moving it means that in essence you are still drawing.

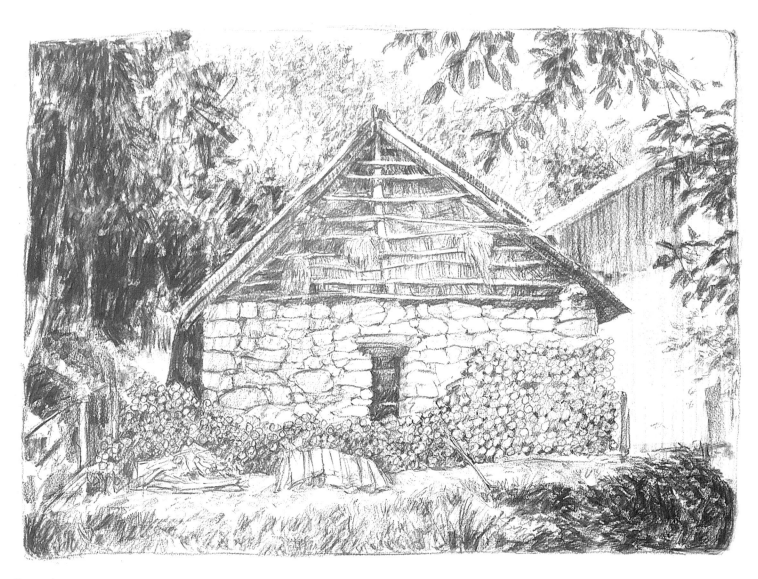

Step 4

This requires final tightening of the drawing with accents and linework. Use both pencil and graphite stick points for variation of density and pressure. The main areas that require attention are the stone wall, the straw roof, and the logs. You will now be getting very close to the fussing stage, where the excitement of previous loose applications can start to look overworked. Keep up your speed and variety as much as you can and step away from the work frequently to check whether it is finished. Note that the finished piece has a full range of values now, from areas of white paper to the deep darks where the graphite has been dissolved. The eye has plenty to become involved in, and the contrasts provide a good expression of light and shade.

LINE & TONE SHADING(COLOR)

Introduction

While shading can be fully expressed in monotone, it can also quite easily incorporate color. By no means essential, color can, nevertheless, bring an extra dimension to the image. Our mind carries many associations with color, which can help to suggest depth and sunlight or even evoke a mood.

Virtually all of the monotone dry media have a compatible color range, from pencils to pastels. Eventually, this path will lead you naturally to paint itself, but for the moment we stay with the spirit that is inherent within the structure of drawing.

A pencil for example — black or colored — can be used to hatch, cross-hatch, and shade. Its line characteristics can be varied enormously to provide either subtlety or strength by blending or exerting varied pressures or partial erasure. All of these effects can be coupled with color.

What can color can do for the picture? The most basic role it plays is to separate one area effectively from another.

A simple example is to take the first stage of an oil painting, when drawing in the main shapes using a brush and one color. Imagine a change was required to the drawing, one that required overworking the previous linework. The easiest method would be to change the color of the line so that it stands out, effectively separating the new section from the rest through the use of color. Thus, the most basic use of color would be the juxtaposition of just two colors.

This may sound limited, but it has formed the basis of some of the most well used techniques employed by artists over the centuries. In this section, a hand rendered in just such a manner demonstrates the technique. The color range, being limited, holds the image together, and the two colors, being of the same family, work well together. These two colors, Sanguine (from blood) and Sepia (an earth color), have a long history and are essential to your drawing repertoire.

Colored pencils are a vastly underrated medium, perhaps because they are so common. Yet they are the natural first step from gray into color.

While pencils can be dissolved gently with thinners, in the following studies they are physically blended with a paper wiper, and the method used relies mainly on hatching and cross-hatching to intermingle the colors.

As we move on to pastels and crayons, we begin to deal more with strokes of color, and we move even closer to painting itself. These are fatter drawing tools and demand a broader approach. However, they do speed up coverage of the surface, and this will eventually instil confidence in the application of color masses.

With the bolder application of colored areas, the rendition of light and shade becomes more easily achieved. You can now be more instinctive and suggestive, rather than fuss over detail.

Enjoy the control that colored dry media has to offer, for soon they will lead you into the direct use of fluid pigment and the joy of painting.

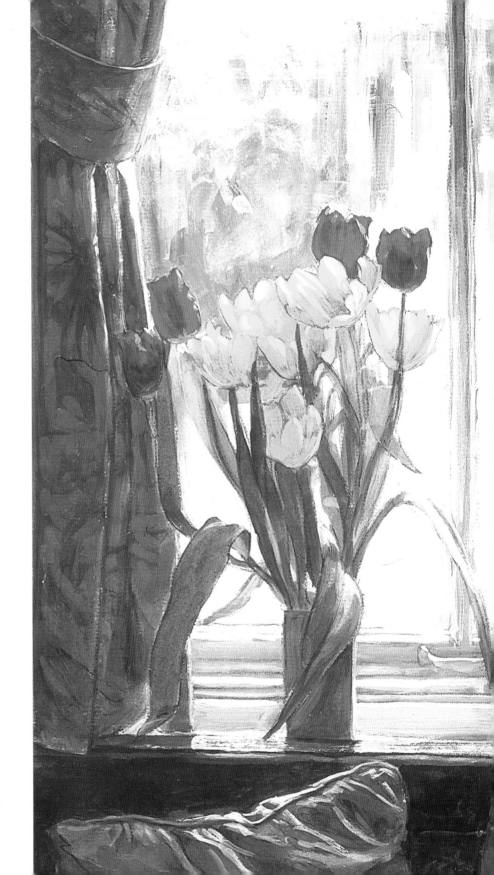

MATERIALS
Colored Pencils
Pastel Pencils
Oil Pastels
Watercolor Crayons
Round Watercolor Brush
Kneadable Putty Eraser
Paper Wiper
Erasing Knife
Various Papers
Hot-Pressed Watercolor Paper

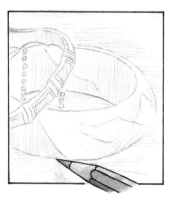

Establish the silhouette using blue pencil. Begin to gently hatch in color to add some solidity.

Use denser hatching to now start to vary the value, suggesting volume.

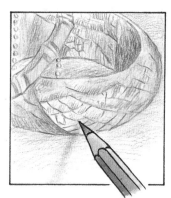

Spread and soften color values with compressed paper wiper.

Finally, develop surface detail.

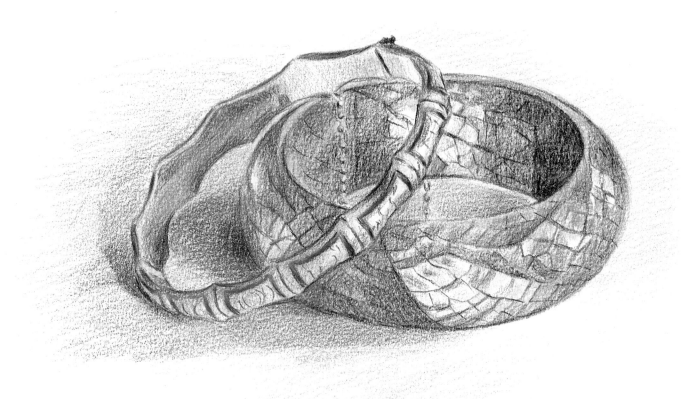

Colored Pencil

So common are colored pencils that few would really consider them a medium of great merit. Yet they have provided most of us with our first steps into color, and will continue to do so. Like a lead pencil, they are undoubtedly slow to apply, but for many starting out in drawing and painting, this boosts confidence, for that which is slow is more easily controlled. Provided that you approach colored pencils with a degree of patience, they will reward your efforts a hundred fold. Look for any object lying around your home. For this study I chose a couple of bangles and placed them in such a way that light hits them from one side, giving the optimum amount of light and shade for the best three-dimensional effect. Start to sketch in the composition with a gentle outline rendered in light blue pencil. Relax your wrist and do not worry about getting

everything right in this first layer. As you slowly build the color with hatching and cross-hatching, there will be plenty of time for change. After you have applied a reasonable covering of color, use a paper wiper to soften and spread the pigment. You can also use a kneadable putty eraser throughout the drawing, provided you are working on a reasonably strong paper that will take the pressure. As you near the final layers, the texture of the paper begins to play a more important role in the overall effect. Look at the texture in the blue-purple shadow to see this. Having completed your first colored pencil drawing, you will be in a position to decide whether the paper on which you were working on this occasion was a benefit or a hindrance. This awareness of the surface will guide your choice in the future.

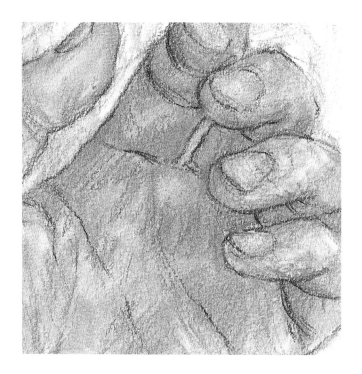

Lightly sketch in main proportions in sanguine. Establish structure with lines and hatch shadows across flesh.

Use paper wiper and kneadable putty eraser to blend linework; then re-establish highlights.

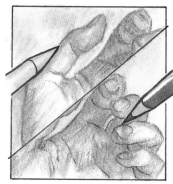

Reassert linework. Soften where necessary using finger.

Judiciously soften again using paper wiper. Apply final descriptive linework in sepia.

Pastel Pencils

Pastel pencils are available in a wide range of colors, and many manufacturers link them directly to their pastel range so that they can be used in combination. If you are trying them for the first time, however, you may not want to spend too much. Your basic kit could comprise of these two earthy colors: sanguine and sepia, which have been the mainstay of many artists' drawings and sketches throughout the ages. While they find their zenith in dealing with figures and portraits, they can, in fact, be used for any subject. Although working with color, the limited range means that you are still only dealing with values. In other words, you are working with color without the worry of color mixing.

Hands are endlessly fascinating subjects to study. After years of drawing them you will always discover something different. In this study, for example, note how the little finger angles in toward the center of the palm. Hands can be expressive, emotive, dramatic, or sculptural, and it is this latter element that makes them an ideal subject for light and shade. Begin the study with the sanguine, going as far as you can to render every characteristic you feel is important. You can soften the color with a paper wiper or erase with a kneadable putty eraser, slowly building up to layers of value and hatching. Eventually, when you have exhausted all the possibilities of this color, switch to the Sepia to sharpen detail and accents and add that final bit of linework, which crisps up the final piece.

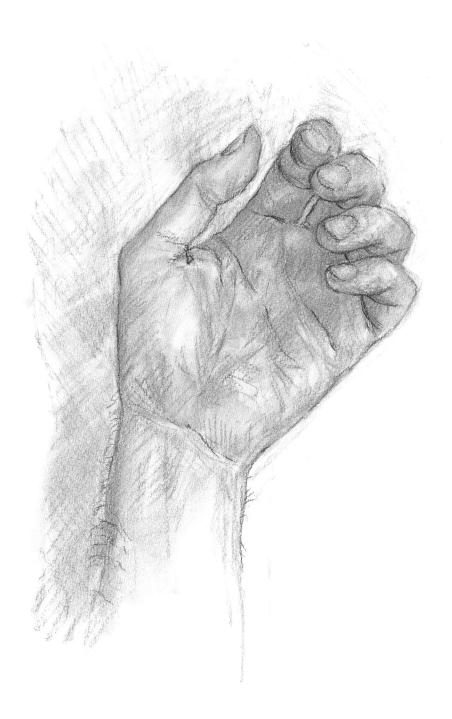

Hatch color together to visually mix on surface.

Gradually hatch in more colors.

Continue until white paper is almost eliminated, so color works against color.

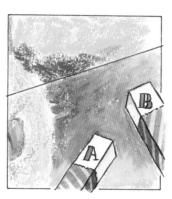

Overlay background with heavy white blending to create recession [A] and soften vignette edge [B].

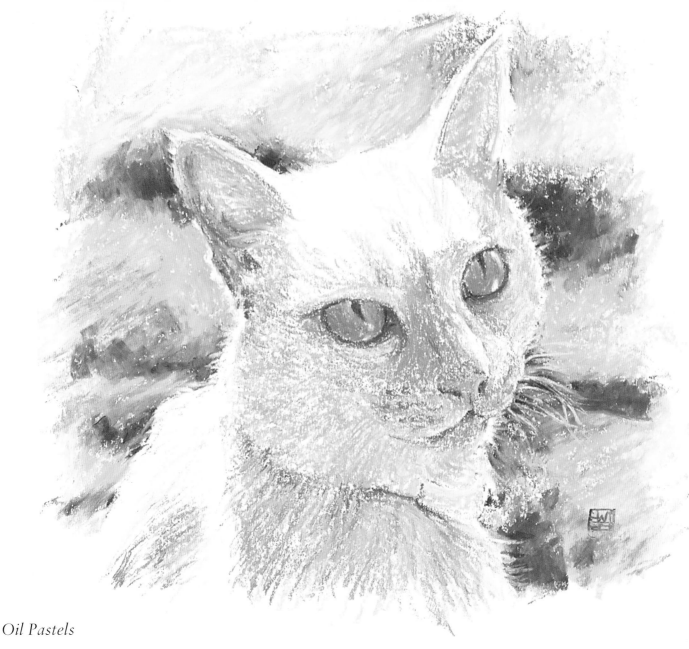

Oil Pastels

Oil pastels are available in a large range of values and hues. By slowly hatching them together onto the paper, quite fine detail is achieved, as the example shows. Start with the basic drawing using a light color, keeping the sketch light and scribbly so that change can be introduced where necessary as the image develops. By hatching the colors next to each other, they mix visually on the surface. As the paper eventually becomes covered, the pastels begin to smear into one another. This can be useful, as it softens the focus; but overdone, it may appear heavy, so be careful not to overwork. Overworking or redrawing is simply corrected by scraping away excess or unwanted color with an erasing knife; then reapplying color. The cat's whiskers were rendered in this manner. Note how little blue has been used in the shadows here. Orange is reflected from all around into the shadows, making them warm. The hint of blue on the right hand side of the face really does look cool against the other colors. If overdone blue can look dirty, so apply with care.

Watercolor Crayons(Aquatone)

While watercolor pencils are available in many qualities and a whole range of colors, watercolor crayons can be considered their big brothers. These hard crayons have a slightly waxy feel when used dry, but they are designed to be dissolved with water to spread into washes. This opens a whole range of techniques, some quite unique. Used as a normal colored crayon, they respond to the texture of the paper so that one gets the smoothest coverage on cartridge or hot-pressed papers. In more textured papers, they ride the surface ridges, and it is only when wet that the color migrates into the lower reaches of the textures. Use them dry to build up color and shade with hatching and cross-hatching, or shade broadly using the side of the large chamfered point. Pieces of crayon can be broken off and used side-on for swiftly shading large areas. The real power of these crayons comes using them wet-on-wet. Wet the surface and dip the crayon tip in water to achieve some really dramatic strokes. Use the tip of the point for detail and its side for coverage, just as you would a brush. The tremendous range of qualities from dry fine hatching to fluid wet-on-wet strokes provides wonderful freedom and fantastic contrasts — just the thing you need to inject light and shade into your sketching and drawing. Watercolor crayons can be combined with watercolor pencils, the latter providing even more detail if required. However, the crayons on their own are an excellent medium to carry out on a day sketching trip, to be dissolved either on the spot or on your return home.

Step 1

Sketch out the main composition using the point of the stick. Begin with a blue (Ultramarine) and block in the general masses before lightly hatching in some color. Be gentle with the application until you get the feel of the strength of the color. Although some erasing is possible with a hard eraser, it is best to keep this stage light so that it can be simply overdrawn with more powerful strokes of color. There is now sufficient information on the paper to determine whether you have achieved a satisfactory balance of elements or whether large changes are required.

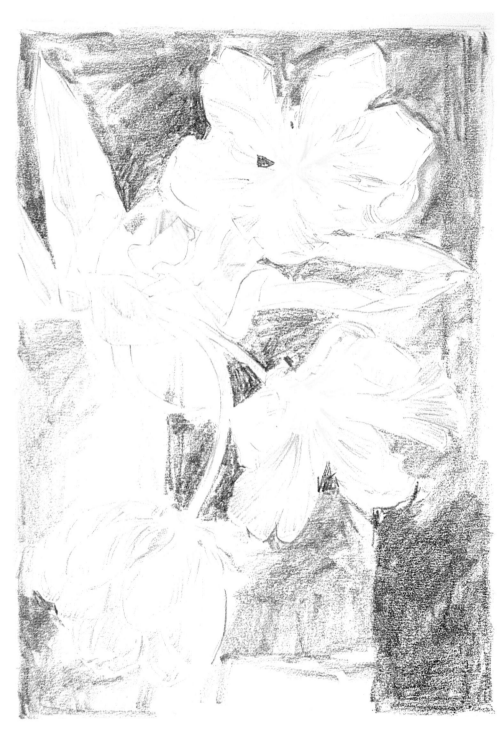

Step 2

Continue to use the point of the crayon to explore the linear rhythms within the flower heads. Use warm reds and oranges to capture the warm sunlight on the petals. The background requires broader strokes from the shank of the crayon point, so break the crayon about 1½" (40mm) from the tip. This enables you to exert more pressure to the point throughout application. Hold the crayon pieces underhand to achieve the correct angle and pressure for this strong color. The colors strokes can be overlapped and thus mixed on the paper surface.

MATERIALS

Watercolor Crayons

Round Watercolor Brush

Hot-Pressed Watercolor Paper

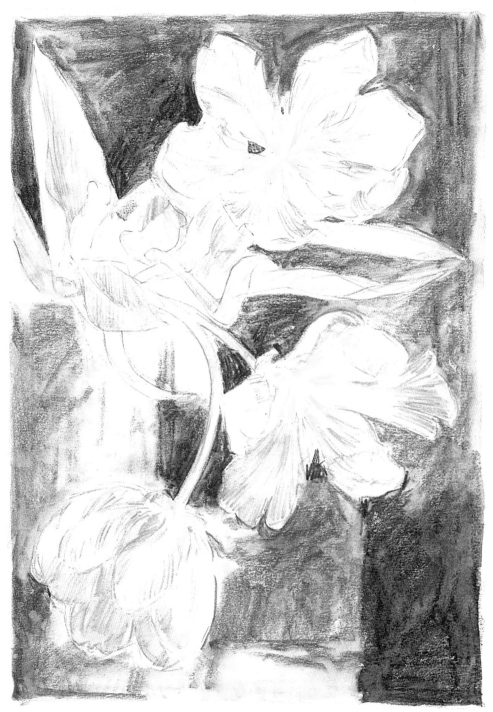

Step 3

Use a soft round brush with a good point to wet the surface and get into corners and edges where necessary. Starting with the flower heads, draw the brush in the direction of the line textures so as not to completely eliminate them as they dissolve. For the same reason, once wetted, do not return to an area until it has fully dried; otherwise, too much pigment will begin to move, destroying your underlying structure. Clean the brush frequently on an absorbent tissue so that unwarranted color mixing cannot occur. Now wet the background colors, paying careful attention to the silhouette of the flower with your well-pointed brush. Sufficient wetting has now occurred to spread the color, and the rest of the study is worked dry from this point.

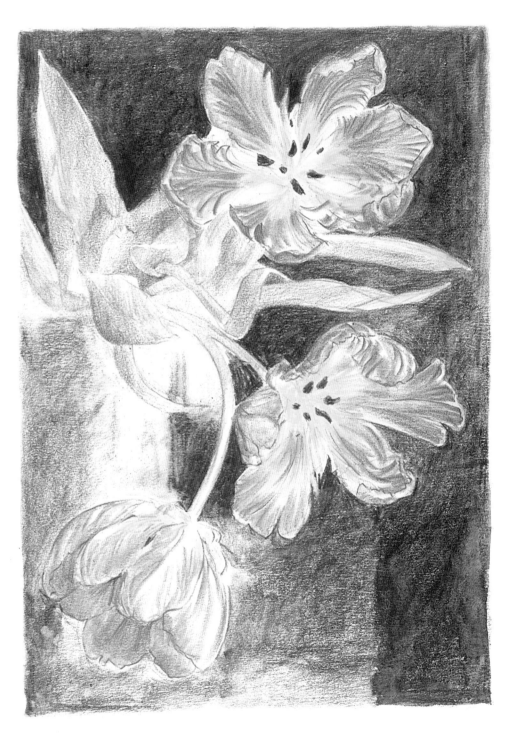

Step 4

You will now find that the dry washes over which you are to work will make the color much more smooth and easy to apply. The crayon, on wetting, has deposited its medium (gum) across the surface, which improves the ground. Powerful descriptive linear strokes are now applied to the petals, in reds and yellows, with the addition of the wonderful black accents to the stamens. Black overlaying color inevitably dulls the latter, but here it is just what the background needs. The purple for example, is far too bright. Using the point flat-on to apply black as shading, both powerfully (background) and gently (leaves), forces the background to recede allowing the intense colors of the flowers to dominate the final picture.

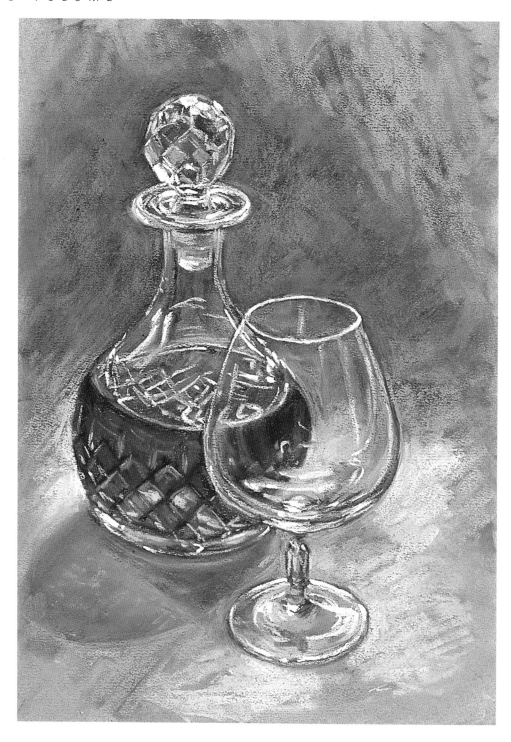

MATERIALS

Graphite Sticks

Sketching Pastels

Kneadable Putty
Eraser

Paper Wiper

Acrylic Paints x 6
Basic Primary Set

Oil Paints x 6 Basic
Primary Set plus
Underpainting
White

Set of 6 Primary
Watercolor Paints

Bristle Brushes

Round Watercolor
Brush

Masking Fluid

Permanent Masking
Fluid

Granulation
Medium

White Candle

Colored Wax
Crayons

Canvas Board

Various Papers

Colored Pastel Paper

Watercolor Paper

Introduction

While creating volume is generally associated in our mind's eye with objects and conversely creating depth is linked with space, it is difficult to visualise one without the other. How can we have an object without space around it and why should we have empty space without any content?

The mainstay of volume however, is that it suggests objects that are solid. Something that is solid has several properties - texture, color, perspective, value or tone and scale. It can be affected by light falling on it and from reflected colors of the objects around it.

How are we to capture these properties on paper or canvas and which should have priority? The only way in which to examine these is to try and deal with them one by one, hence the section that follows. Often however, it is impossible to isolate one particular quality in an image.

While dealing with color for example, texture will often creep in as well. All that we can really do is look at subjects and techniques that prioritise a particular quality. If, during the drawing and painting process, you concentrate your efforts on that quality, it will not matter too much if others are present to a lesser degree, for you will have learned so much along the way.

First we visit the most important aspect involved in the creation of volume, that of controlling the light and dark tones as they modulate across the surface of an object.

Color needs to be isolated from the whole image so as not to interfere, and what better than to select objects that are white in the first place with a pencil sketch of white ducks. This is a fascinating exercise, for by following it you will discover just how dark "white" can become as it falls into shadow.

By controlling the tones of black and white and the values of the colors, we can make an object appear three-dimensional.

However, what happens when the object is transparent? By completing a pastel study of glass you will see exactly what happens, while also gaining insight into the necessity to control focus. The decision on whether a colored stroke should be hard or soft is one of the most important in painting and essential for creating volume.

What about color itself? You have read earlier of the concept that warm colors advance and cool colors recede. Can this be used as a natural part of the painting process to create volume and light? All is revealed in a flower study in this section.

The direction of the brush marks plays an important role in establishing volume.

I liken a brush to a tool with which to carve out space, not unlike a sculptor's chisel, where each stroke whittles away the surface and leaves evidence of its passing. Being painters, our space is of course an illusion and our medium is color.

Finally, the step-by-step demonstration puts many of these elements together, but adds a large dose of texture to the objects. As the best still life studies inevitably carry a multitude of textures, this is no exception and you can enjoy the challenge of divining the differences between painting a tomato, a dry cracker, and a piece of glass in watercolor.

Graphite

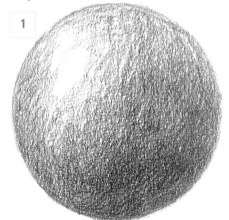

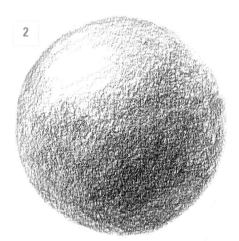

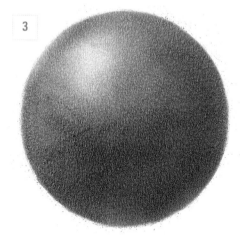

1. Shading executed in 2B pencil. This is effective but tedious. Overlapping strokes and slowly increasing pressure develops the density. Any paper texture is revealed, as graphite fails to find lower reaches of this surface.

2. Flat edge of graphite stick point is used here. This is faster and the broader graphite surface skims the paper texture even more. This could be a nuisance or a boon, depending on whether or not you wish to bring this effect into play.

3. A paper mask was used and graphite shavings dropped into the unmasked area, then worked in with a cotton wool ball. This gets down into the paper texture, ensuring denser coverage. Note the soft edge where some of the graphite migrates under the mask.

4. Following the same process but taken through to reworked highlights, using a kneadable putty eraser. The whole is then covered by the central circular piece cut out from the previous mask. By working around its edge with the kneadable putty eraser, the edge is sharpened and cleaned.

5. Following the same route, but given final texture using a pencil as in 1. These final accents could be general texture as shown, or form a pattern on the surface.

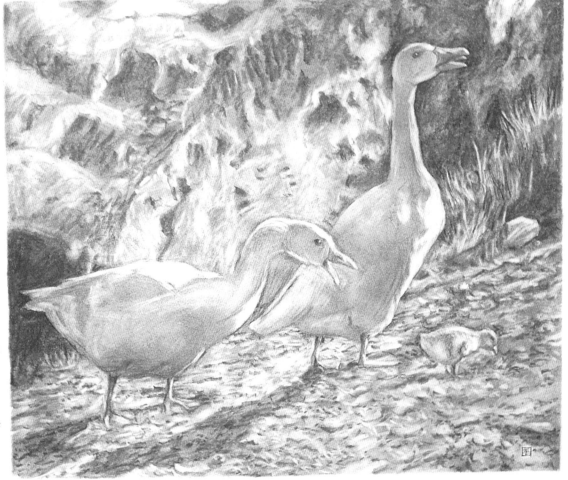

Creating volume with pencil more often than not brings to mind a tedious process in which shading is gradually built up using the edge of an HB pencil. No wonder that at some stage we have all felt that there was an ocean of difference between drawing with a pencil and painting with a brush. However, there is no need for this to be the case, for drawing with graphite can be every bit as exciting and certainly as fast as working with color. Not only will you then have a technique that brings you much joy, but also such a drawing will have already prepared you for the manner in which a painting of the same subject could be tackled. The secret is in the graphite stick. Made of solid graphite, it can be shaved onto the surface or applied directly, covering the surface swiftly with a good layer of graphite. This eliminates the white paper entirely, and the white can then be reintroduced by erasing the graphite layer with a kneadable putty eraser. In effect, you are reversing what would normally occur in a graphite drawing, since you are working from dark back to light. The results at this stage can be quite startling, but darker accents can be achieved where and when necessary with the point of the graphite stick or a normal pencil. Certainly, the technique is swift and suitable for sketching on the spot to capture light and volume. Taken to its extreme, however, it can be used as a medium in its own right to provide a finished drawing with all the attributes you might require from a work of art.

Sketching Pastels

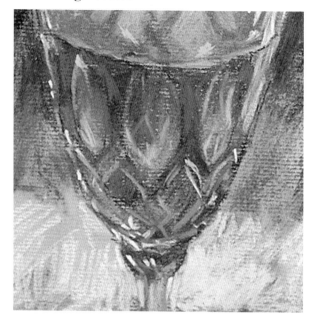

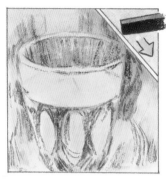

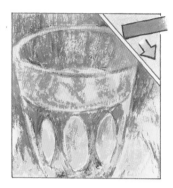

Limited color range demands use of black for accents.

Black is enriched by overlaying middle value colors.

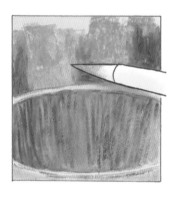

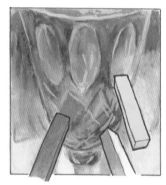

Blending solidifies color blocks.

Reapply middle value colors to once again add richness to the black.

TIP
Sketching pastels are usually available in a limited range of colors. This often necessitates the use of black to bolster the strength of values necessary for contrasts. By overlaying black with other colors, the black becomes less strident and emerges as a dark color.

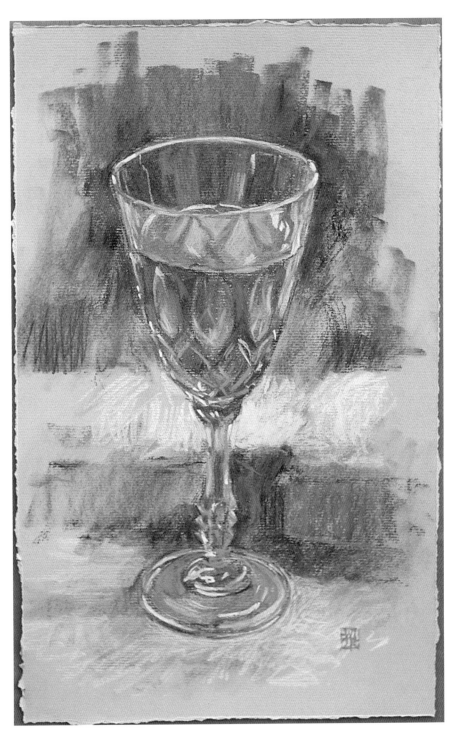

Careful manipulation of light and shadow in an object can create the illusion of volume, but just what happens when the object is transparent? As the light passes through, it does not spread evenly across the surface to give a gradual modulation of value. Instead, colors and values from behind the object are distorted by its shape. This visual squeezing and pulling will stretch and/or condense the colors, often producing close contrasts within the object. Half close your eyes and note how close accents and highlights lie when observing a piece of glass. Highlights, too, follow the contours of the surface. These are laid over the colors that reach us from behind. In pastel, the natural progression is to build all the dark and middle values first, applying the highlights as a sparkling finale. Note how the colored paper provides a medium value from which you can move toward dark or light. The empty glass is composed mainly of the colors from behind, with some highlights reflected from other parts of the room unseen by the viewer. When the glass is full of liquid, the colors would change, but there is a similarity in approach in that values, whatever thier color, are condensed and contrasted as in the clear glass. Finally, look out for the differing qualities across the surface. Where have pastel strokes been left untouched and where have they been softened or blurred into the colors around them? Softened strokes recede, and untouched strokes come forward, helping to increase the sense of volume.

Acrylic Paints

Working wet-on-wet with acrylic is simple, as dried underlying color is permanent.

Opaque color can now be applied wet-on-dry and worked back from dark to light.

Mixing acrylic color with the brush tends to overload the head — not good for painting.

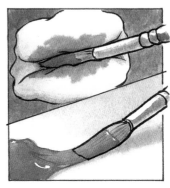

Squeeze out excess on a tissue and reload, flattening the brush on the palette.

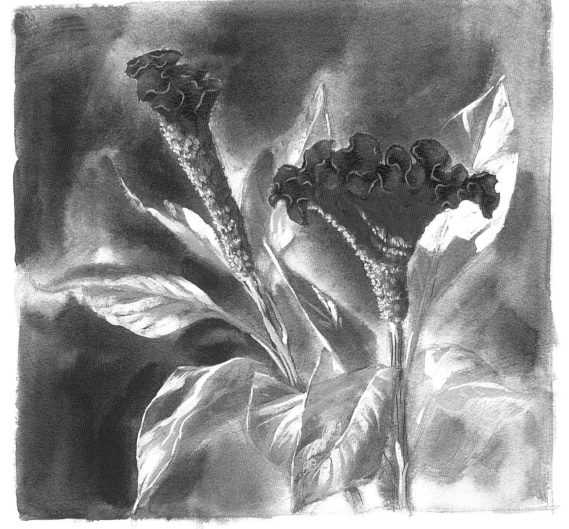

Working in acrylic paint probably provides the widest range of possibilities for creating light and shade than any other wet medium. In this study of an exotic flower, the image is started as one would a Wet on Wet watercolor painting, flooding the pigment on to the wet paper surface. However, there are two distinct differences. First, when the paint dries, it will be permanent, and will be easy to overpaint without bleed-through from below. Second, these first colors can be applied darkly, secure in the knowledge that lighter colors can be overlaid. Both flower and leaf are thus solidly applied yet retain soft, unfocussed edges due to the wet surface. Once dry, they are both overpainted using wet-on-dry layering of colors, gradually building the color back toward the light highlights. The finished piece displays incredible variety. In the blue-gray background, it is the paper that provides the light, as one would find in a watercolor. On the other hand, the leaves have cool highlights, provided by the paper and warm yellow highlights created by the build up of opaque acrylic color. At the other end of the scale, the flower lights are pure pigment. Here the darks, which show through from the first layer, have become the accents. Such versatility allows ample scope to capture not only the interest of the eye, as it moves across the variegated painted surface, but also the imagination, as you consider the subjects to which this technique could be applied.

Oil Paints

IMPASTO TEXTURE & DIRECTIONAL STROKE

One of the most unique aspects of working in oil paint is the ability to build up layers and strokes of thick paint, a technique known as impasto. It is especially effective in oil paint due to the fact that the paint dries through chemical reaction with the air, rather than evaporation. Because of this, the paint layers do not shrink but simply harden, retaining every detail of their texture. For this exercise you will need to use Underpainting White quite heavily in the mixes. Of all the available oil painting whites, this is the fastest drying and is very stiff, creating excellent impasto. It is also less likely to crack when used heavily. In the cross-section diagram, you will note that the brushstrokes have been applied over a prelaid, dry, flat color, which is also evident in the top left section of the fruit. This enhances the definition of the applied brushstrokes so that you can readily see that the direction of their application plays a major role in suggesting volume. Adding the white inevitably makes the oil color slightly chalky in appearance, but at this impasto stage you should be keeping your mind on the texture. Color intensities can be modified by the glazes that follow.

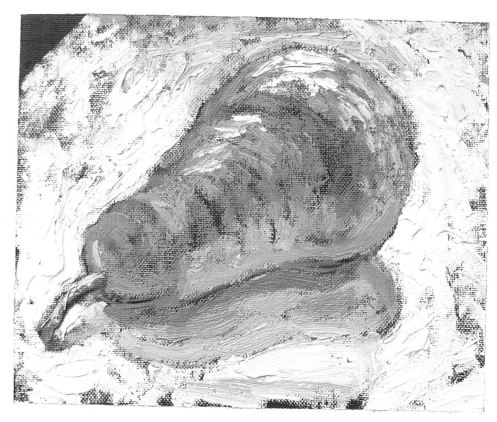

GLAZING

Transparent colored glazes, applied as thin washes, now enhance the impasto textures. The fluid color discovers all the nooks and crannies of the impasto, as can be seen in the cross-section diagram. For those of you who have found oil painting a little flat, it is usually because you are not using glazes to enrich color and texture. Here the concentration is on texture, with a predominance of warm glazes being laid over the cool impasto layer. This complementary layering has the effect of creating dull, darker colors as the pigments absorb more light. The resultant dull coloration does, however, allow the texture to predominate, as it is not competing with intense color. As each brushstroke now becomes a vehicle for the glazes that describe every groove along its length, our eyes not only follow the strokes but also the texture within. Volume is enhanced and the surface becomes painterly and full of excitement.

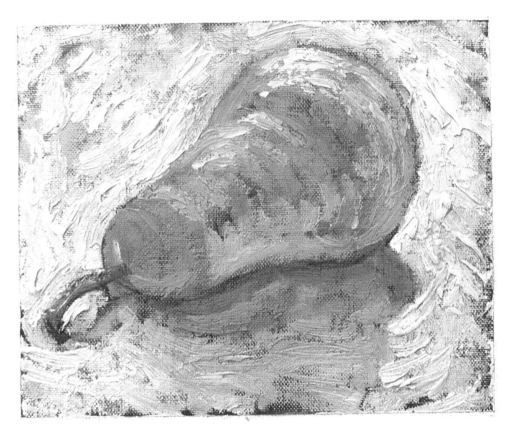

Watercolor Resists

CREATING VOLUME THROUGH CONTRAST
AND VISUAL TEXTURE

Still life subjects have provided countless generations of artists with inspiration, and they still manage not to disappoint no matter what your style or medium is. For this step-by-step tutorial, a very traditional set-up has been arranged with a variety of colors and textures to excite the eye. To bring out the strongest sense of volume, it is sensible to use sidelight to illuminate the subject. In this way we have the full range of values, from highlight to accent, amply displayed. A still life provides the artist with one of the most controlled subjects to paint. Not only can the direction of light be exploited, but also the subject itself can be arranged and rearranged until it satisfies one's personal taste. It isn't always best to go straight into the first set-up, produce a quick sketch, and see how the composition looks when confined within a rectangle. Be self-critical at this stage; you can afford to be, as you haven't made any commitment by setting brush to paper yet. More often than not you will arrive at a better balance as you begin to understand your subject. All of the objects in this still life will last a few days, so there is no hurry to get going. An exploratory sketch could indicate there are too many objects, or perhaps too few. Perhaps one of the objects is too small, or too large. If the latter is true, you may have two options: change the object, or possibly manipulate its size in the painting. While

this isn't always possible, it is worth noting that the wedge of cheese in this composition is thirty-percent larger than it was in reality. After all, it is the painting that is important and what it imparts, not whether it is a photographic replica of the original.

Step 1

Stretch a sheet of watercolor paper, and when dry, loosely sketch out the main elements in the composition. Ensure that on this larger scale they still all balance out. Overlapping shapes always help to create a feeling of volume and depth, and you can see by the drawing that plenty of these have been included.

MATERIALS

Set of 6 Primary Watercolor Paints • Round Watercolor Brush

Masking Fluid • Permanent Masking Fluid

White Candle • Colored Wax Crayons

Granulation Medium • Watercolor Paper

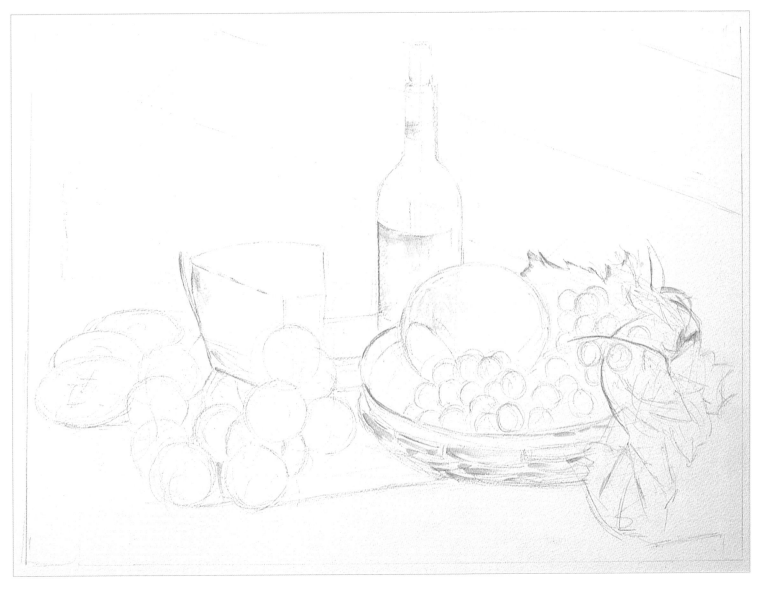

Step 2

When applying the color, you will need to be bold to render all the values required to create dramatic volume. To build watercolors to the desired strength, you will need several layers. In each case it is going to be difficult to paint around small, bright highlights, so it makes sense to capture these now using masking fluid, which can be seen in place at this stage. Permanent masking fluid was applied to the highlights of the tomatoes, some grapes, glass top, and bottle. These can't be seen now, but will become apparent with the application of color.

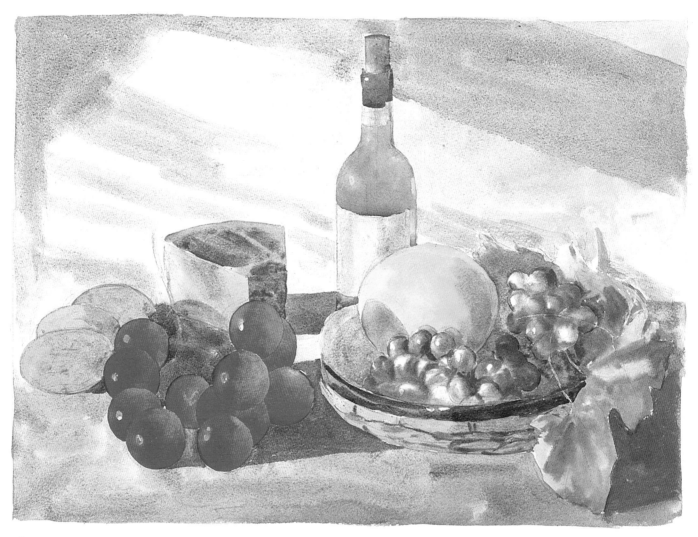

Step 3

The first highlight washes are rendered as variably as possible using two methods. First, granulation medium is added to the broad washes of the background to excite the texture. Second, washes are varied in both color and value, as they move over and around objects. Examples of this are to be found on the bottle where a color change from blue to yellow-green is achieved. The tomatoes move from a pure Cadmium Red (Ro) on the lit side to a solution of a duller orange (Ro+Yo+touch of bp). Even the background wall becomes darker to the right hand side. A large round brush with a good point is essential for holding sufficient color and allowing accurate painting to crisp sharp edges.

Step 4

When the masking fluid is removed, you can see its sharp edges against those softer ones caused by the permanent masking fluid on highlights such as the tomatoes. Both can be adjusted by lifting off more color. Only those created with nonpermanent masking fluid can be colored or textured, however.

Step 5

Many of the highlights revealed in the previous stage are given color, ensuring a predominance of yellow in their mixes to suggest the warmth of sunlight. Many of the following changes that are completed now will be easier to see as color is applied over them.

Candle Wax Resist: Applied to mid lights of the wall, left hand side of the melon, as a halo around the grape highlights, and to the lights and reflected lights of the tomatoes.

Colored Wax Crayon Resists: White to soften shadow edges. Brown hatching to establish surface on wall, to stems and leaves, to glass, straw bowl, cheese, and crackers.

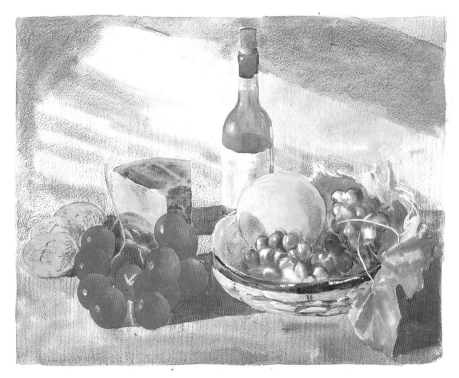

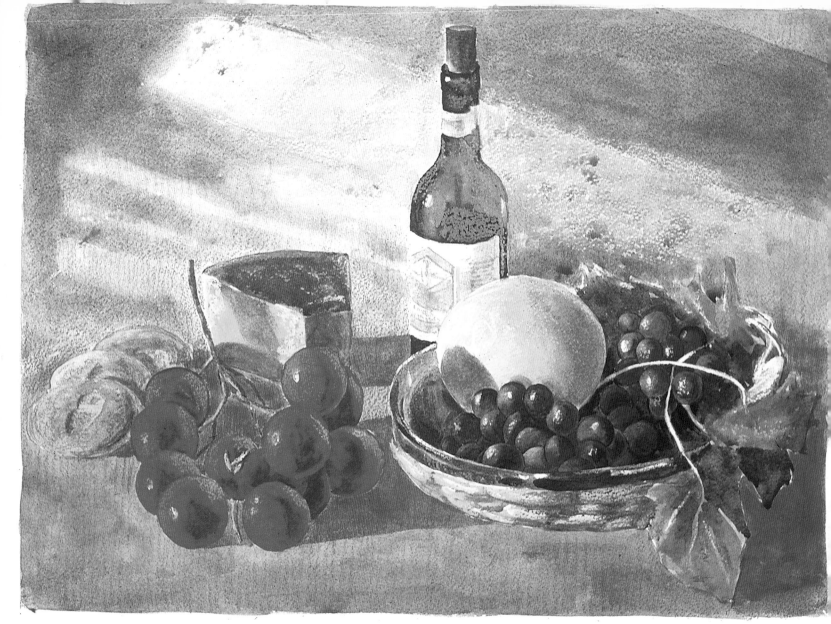

Step 6

The volume of the objects are now more strongly established with washes, which also being resisted by underlying wax, create texture. These washes are found over the background, the glass, the leaves, and the tomato stems. The washes to the tomatoes and grapes are interesting in that in the former, the dark washes are lost to the right with thinner washes of Cadmium red, which finalize their reflected light. The darker, deeper washes are applied on the right and are lost toward the lit edge on the left.

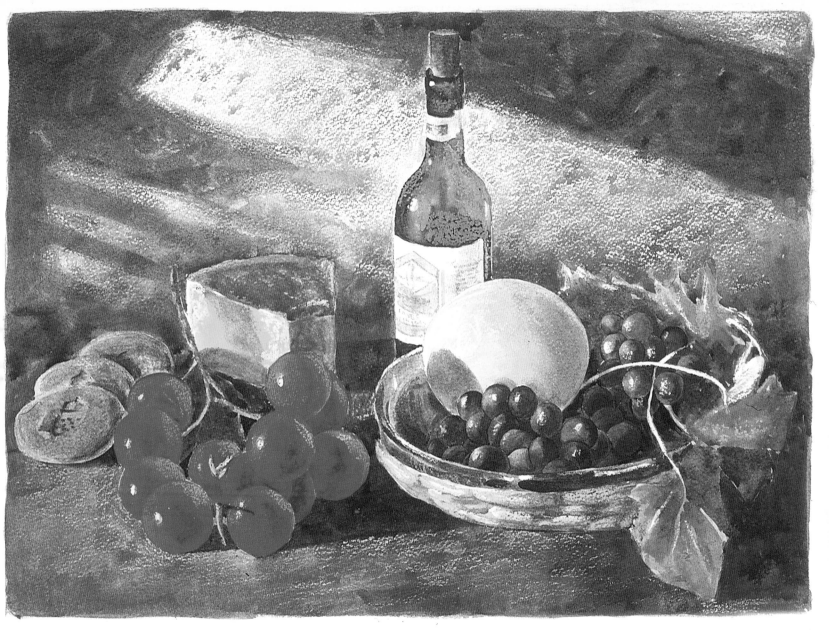

Step 7

Establishing stronger contrasts in the space around the objects provides light, depth, and volume in which the still life can sit. First, some final resists of orange and white wax crayon to the foreground, from the shadow edge, establishes the solidity of this surface. Candle wax crisps up the texture of the surface of the crackers. Starting with the left hand side, the dark ground and wall washes are painted wet-on-dry, moving in an counterclockwise fashion around the painting until arriving back at the left hand side. This continuous but constantly varied wash holds the painting together. Generally, it is warm over cool areas and vice versa, adding variety to what could otherwise become rather flat in terms of color.

MATERIALS

Set of 6 Primary
Watercolor Paints

Set of 6 Acrylic Paints
(Basic Primary Set) plus
White

Set of 6 Oil Paints (Basic
Primary Set)

Soft Pastels

Round Watercolor
Brush

Bristle Brushes

Masking Fluid

Oily Thinner

Kneadable Putty Eraser

Canvas Board

Watercolor Paper

Colored Pastel Paper

CREATING DEPTH

Introduction

In spite of having a vast array of painting techniques at my fingertips and having painted for so many years, I never fail to get excited when a painting finally starts to take shape. Light emerges from a few scraps of paint and the surface disappears, engendering the feeling that one is looking into space. This is pure magic, and I must confess to experiencing a tremendous thrill when demonstrating this to those who are learning to paint.

Pastel and oil painting demonstrations always create the most stir, for they look so terrible at an early stage. I can almost feel the waves of sympathy as the audience thinks to itself "How is he going to get out of this mess?" after I have applied the first dull and seemingly dirty layer.

Providing I do get out of the mess, the finished result is always that much more rewarding than if it had looked wonderful from the first brushstroke. This is the barrier we all have to cross during the course of producing each and every painting, no matter how experienced we become as artists. With pastels and oils one must have the early darks so that subsequently painted layers of light values suggest light and depth. Watercolor and the

acrylic paintings, which start light, conversely require the dark shadows and masses to follow.

Depth in a painting is achieved in a number of ways. First, there is the phenomenon of aerial perspective.

Aerial perspective is created by the atmosphere affecting objects as they are positioned progressively further away from us. Color coming from these objects is leeched away, becoming lighter and bluer the more distant they become. The color blue travels further than any other color through our atmosphere, hence the blue sky.

There is also a dulling of the color, and often the water vapor in the air creates a misty effect, which blurs the outlines of the object. Thus, we have four changing properties; value, hue, intensity, and focus. In some cases all of these changes will happen at the same time, but often you need only one of them to satisfy the eye.

For example, how can you make a blue ball bluer with distance? The simple answer is you cannot, but you can make it lighter. If it is already a light blue ball, you can resort to making it duller or soften its edges.

Linear perspective, on the other hand, is all about lines and edges and is the traditional perspective used for buildings, when creating a technical illusion of depth.

Linear perspective is not tackled in this book, as we are concerned more with creating depth using light and shade. Both can, however, work sympathetically toward the same end, and some examples are shown in the following section where this is the case. This will give you a starting point when facing linear perspective in your own compositions.

Watercolors

ARTSTRIPS

AERIAL PERSPECTIVE

A strong element of aerial perspective is the variation between the value of highlights and accents, according to their distance from the viewer. In the two segments isolated from the study, you can see the way in which this phenomenon has been used. The segment from the distant trees has soft lights and medium value accents, whereas the foreground segment has white highlights and very dark accents.

Overlapping planes of differing value suggest depth. Normal recession requires that values move from dark to light into the distance.

HOWEVER as long as shapes overlap, depth is created even when expected values are reversed.

This effect is accelerated if colors are also made to become more blue and dull into the distance.

This is aerial perspective and is caused by layers of atmosphere that distort the colors.

This simple watercolor sketch is one that could easily be completed on the spot. The technique, being Wet on Dry, would not necessarily require stretched paper, and could, therefore be painted in a sketch book or pad. There is some masking, with masking fluid, in the foreground bush and on the left hand side of the bridge and the foliage above. Once removed, the former is left white while the bridge is given a gentle pink wash with the surrounding bush receiving a yellow green light. Note how the horizontal bridge, which could be visually boring and carry the eye out of the picture on the right hand side, is saved by counterchange. Simply put, this means that it is light on the left and dark on the right which is causing the eye to hesitate as it moves across. A strong element of the picture is the contrast the building makes with the distant trees behind. Contrast along the edges of such areas creates sparkle, so when painting such, remember that watercolor lightens on drying. Slightly overplaying the contrast during painting often results in a more satisfactory result once it dries.

Acrylics
SOFT AND HARD FOCUS

Be aggressive with the pencil drawing and erasing. Acrylic paint will cover pencil and strengthen the paper.

Build soft, strong darks using the Wet on Wet technique.

Mix stiff opaque color (adding white) to load and shape round nylon brush.

This will then deliver mix to the dry surface as scuffs or line detail.

Often, painters are faced with the job of painting hair or fur, whether in a human portrait or that of a pet or animal. Not only does the surface have to look soft, but it must also carry color, texture, and the values just like any other object in light and shadow. The secret is to keep the focus soft for as long as possible. This prevents hair from looking stiff and allows the whole to be modelled in space. Beneath all hair is color, whether it is the skin itself or simply the shadow of the hair. While this color is important, it must be below the surface of the hair. In this study of a puppy, there are powerful rhythms moving through the curly hair. As you paint such a picture, it is easy to become captivated by the immediacy of the fine highlights. You must, however, just look behind them at the soft, unfocussed details. Without these to contrast against, the sharp highlights would have no strength. The study, completed in acrylic paints, employs the watercolor technique of Wet on Wet to achieve these first soft, dark washes. Color layers are flooded on until satisfactory dark layers result. Only then can we begin to build back toward the light, but you must have patience for acrylic dries slightly darker and more transparent. This means that several layers are necessary to attain the bright highlights required. Your patience will be rewarded, for this gradual build up of soft darks — followed by sharp highlights — can achieve depth and softness, bringing you pleasure to paint and captivating the imagination of the viewer.

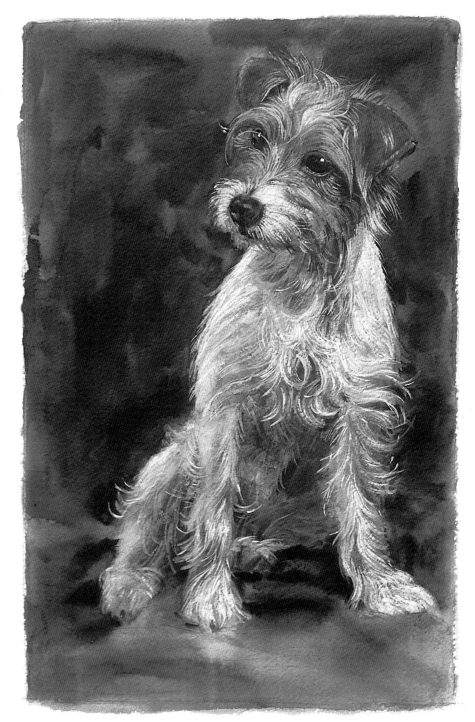

Oils

DEPTH OF REFLECTIONS IN WATER & LINEAR PERSPECTIVE

There is nothing so exciting or frustrating as sitting by a stretch of water attempting to capture reflections on paper or canvas. To make the most of reflections, you need to first understand why the reflection is behaving as it is, and second how to capture it.

Here the bridge is reflected in a perfectly calm surface. Its distance from the water beneath can be determined at the edge of the jetty (red circles). The top circle represents the depth of the jetty the bottom circle, the depth of its reflection — both are equal. The wavy line is drawn from the water's edge, in this case directly under the bridge so that its reflection can be drawn at exactly the same depth (green circles).

The water surface becomes agitated, and the reflection elongates. The more disturbed the surface, the deeper the reflections.

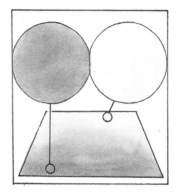

Think of the water surface as a flat plane. The values reduce in strength into the distance.

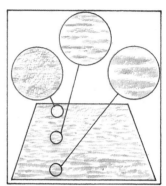

Textures on this surface diminish from individual brushstrokes in the foreground to scumbles in the distance.

Linear perspective in the buildings leads the eye to distant vanishing point.

Trees and lights are not so regular but still focus the eye and create depth.

At twilight, distance and depth become deceptive. The eyes are faced with difficult contrasts, especially at sunset. These can be so powerful that they are often impossible to capture successfully with a camera. Against a bright sunset, the landscape is often only recorded as a black silhouette. The artist, on the other hand, can balance the soft darks of the shadowed land with the brilliance in the sky. Nevertheless, there are less obvious indicators of depth than there are during daylight hours. Therefore, the artist must leave as many visual clues as possible to help the viewer to see into the depth of the painting. The effect is achieved in this example through the use of subtle gradation of value and brushwork, with a little linear perspective thrown in. Fluid brushwork in oil painting can be achieved by working wet into wet. Here, the softness and fluidity are enhanced by adding oily thinner to the color mixes. This medium can be bought or mixed at home using equal amounts of Artists' Distilled Turpentine and Linseed Oil. The linseed oil slows the drying time of the oils, which allows plenty of scope for reworking the surface.

Soft Pastels

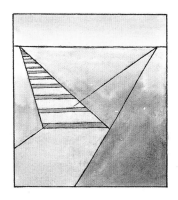

Resembling a railway track, the banks of the river are parallel. Running level they appear to meet on the horizon at a vanishing point.

HOWEVER at a certain point the river changes direction and heads toward another vanishing point.

This can occur any number of times. Since the water is naturally level, the vanishing points will always be on the horizon.

Although trees do not have the rigid perspective of buildings, since they grow parallel to the river, they have a regularity that can be harnessed to suggest depth.

The textured surface of this pastel painting may lead you to think that it must be painted in oils at first. On close inspection, you can actually see brush strokes and textures. This is achieved by underpainting with acrylics, which not only provide texture but also the dark values — essential for creating the necessary contrast in a painting of light and depth. Depth in this composition is achieved in several ways. In the foreground the dark accents are strong as are the highlights on the grasses. Compare these to those on the distant trees. Here the dark accents are actually only a mid blue-gray. This difference immediately alerts the eye to a change of depth. Look at the focus. Distant tree trunks are blurred and indistinct. Nearby grasses and water's edge are sharp. This difference of focus indicates depth. Finally, there is linear perspective. Normally, you would not expect to find linear perspective where there are no buildings. However, by careful examination you will find that its properties can be exploited after all. Simply being aware of the position of the horizon can help enormously as the Artstrip shows. Even if hills or trees hide the horizon, it is the place where the sky would meet the sea if you were standing on a beach. Visualize the horizon in this way and you can create levels and vanishing points that will greatly enhance the illusion of depth.

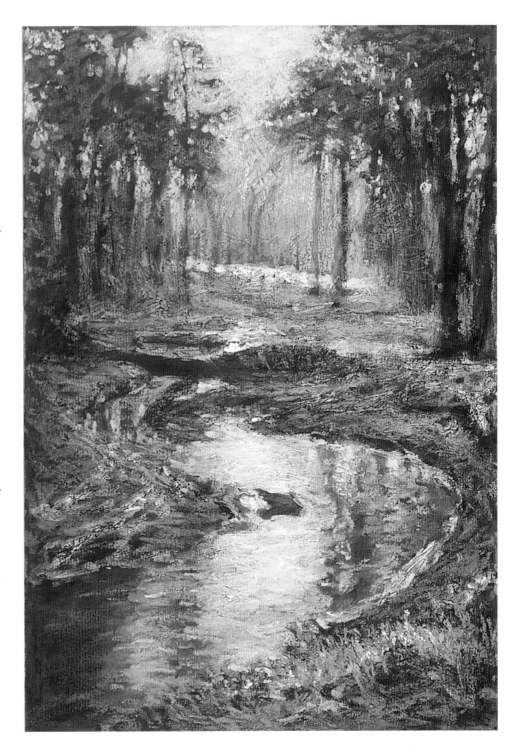

Watercolors

While building layers of watercolor washes has a long history, the concept of building texture into the paint is relatively unusual. Gel-like mediums have been around for some time and help to render the paint stiffer for scuffing and knife work. Recent additions include texture mediums that have a gritty quality. Thus, depth can be created working light to dark with textured layering. In this step-by-step, the medium is added to the mixes of each layer. Even in the first layer the quality of the watercolor is changed in a quite unique manner. By the time the second and third layers are overlaid, their interaction causes some interesting surprises. If you are already familiar with watercolor but haven't tried this medium, then be prepared for some exciting variations. Should you be new to watercolor, then incorporate them immediately in your repertoire of watercolor techniques. Interestingly, this example reverses the range of color temperatures to which you would normally turn in order to achieve depth. Aerial perspective usually relies on colors becoming cooler as they become more distant. Here we have cool green in the foreground, moving through warm yellows to hot orange and browns in the distance. The aerial perspective is served, instead, by

a strong change of value from dark to light in the distance. Thus, the cool greens appear to be eclipsed in shadow while distant tree colors shine in the full blast of sunlight. It is often the case that the most stunning images are created when reversals of normal light or color behavior occur. When they do, it is valuable to know what is happening and why so that you are in control of the phenomenon. Always remember that aerial perspective only requires one of its criteria to be fulfilled in order to play its role fully in creating depth.

MATERIALS

Set of 6 Primary Watercolor Paints

Round Watercolor Brush

Nylon Bristle Brush for Water-Based
Oil Painting

Watercolor Texture Medium

Watercolor Paper

Step 1: Highlights

The aim of this first layer is to lay the structural highlights of the image. As a by product, you will also be covering most of the white paper so that colors can be seen against color, even when very light in value. Darks are to be overlaid later on top of these highlights. Pour a good amount of the texture medium into a separate palette with deep wells. This is added to each mix. Where instinct tells you to add water, try adding the medium instead so that you are as generous as possible with the amount of medium added. Application should be wet-on-dry in order to retain the integrity of each brush stroke. Try to become aware of the flow or pattern that brushstrokes make as they intermingle.

Step 2: Mid Values

Addition of the medium to the mix slows down the drying time of the watercolor. When the second layer is applied, the first may still be wet. The heavy textures hold the first layer in place, however, so you may be happy to continue. The wet surface allows sgrafitto or knifing out, (where both second and first layers are scratched or scraped through to the white of the paper beneath.) Work right through the painting with the middle values of color. Inevitably the brush does bulk out (becoming very fat) with the thick medium. It helps to use the nylon bristle brushes that have been developed for water-based oil painting. Even these stiffer brush heads, however, become bulky with paint, so you will need to frequently flatten them or scrape off excess paint on the side of the palette.

Step 3: Accents and Definition

Don't be tempted to move to smaller brushes, for the medium is simply too heavy. Keep on flattening or shaping the brushes on the palette instead. The flattened side provides texture and the edge linework. Previously laid texture constantly distresses fresh brushstrokes. This affects both the way the surface picks up the color and the way in which it is absorbed. Close examination of the tree trunks will provide you with some idea of the possibilities. Large washes on areas such as the forest floor can have accents applied while still wet. Scuffing is made intriguing by the uneven absorption of the surface, which breaks each brushstroke into unexpected textures.

Introduction

Many years ago, with the aim of developing my skills in oil painting, I spent a full summer outdoors. No matter what the weather I would pack all my painting gear onto a bicycle and off I would go into the early morning light looking for a subject. Soon my easel would be up and, with waterproofs close at hand just in case, the painting would begin.

My main preoccupation then was in gaining a better understanding of just how oil painting worked; the subject was usually of secondary importance. The composition was, nevertheless, well planned and there is always something of interest to paint once you open your mind to the possibilities.

However, in regard to the light and color, I simply painted what was in front of me. So involved was I in the paint and the balance of the composition that effects of light did not really strike me until summer had ended. Only then did I set out the completed paintings in my studio so that I could chart the progress made over the previous months.

What was most significant was the light that came from each piece. Those painted on a dull day were flat and unimpressive while those produced on a sunny day were full of joy and verve. You might observe that was inevitable and obvious, but what is obvious in hindsight is not always so when you are there on the spot.

Suddenly I realized the importance of sunlight, and by looking at the paintings I could better understand the differences in the color mixes and values involved in creating it.

My work changed overnight. Not only did I look for subjects that had light as an important aspect of their structure but I also knew how to incorporate it, even if it wasn't present in nature. All summer long I had waited for sunlight to hit a particular object. Sunlight moving across a forest floor, for instance, can touch a leaf or a piece of bark, creating a spotlight against the rich darks all around. Now I could place that sunlight wherever I wanted and was freed from the constraints of the photographer, to be given the wings of an artist.

Working en plein air (outdoors) is very important to your development, for it teaches you everything about light and its effects.

Working in oils is useful because they are least affected by rain when working outdoors. Taking watercolors or pastels out on a clear day will equally improve the fluidity and speed of your work. The experiences gained will prove invaluable.

Nothing quite beats mixing a tree green only to find that as the sun comes out, the color changes before your very eyes! This is when you really get to grips with color mixing, for you are faced with the ever-moving feast of nature's palette.

Each of the following studies and the step-by-step demonstration are designed to get you started on the road of understanding how to make the most of sunlight and shadow. They feature all of the principal media, including mixed media, and in one section you will find an opportunity to use some ordinary household paint, proving that you don't need to spend a fortune to exploit all of the possibilities that sunlight and shadow have to offer.

<div align="center">

MATERIALS
Oil Paints x 6 (Basic Primary Set)
Set of 6 Primary Watercolor Paints
Acrylic Household Paints
Soft Pastels
Set of Sketching Pastels
Brush Pen
Bristle Brushes
Round Watercolor Brush
Household Paintbrushes
Canvas Board
Watercolor Paper
Kneadable Putty Eraser
Masking Fluid
Colored Pastel Paper

</div>

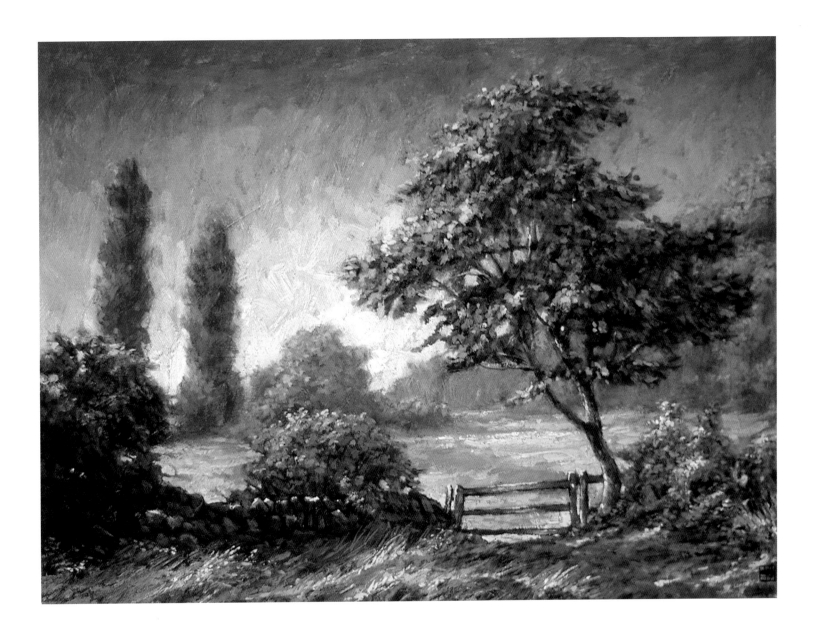

Oils

ELEMENTS ESSENTIAL TO SUNLIGHT

VALUE CHANGE:
Removing the color exposes the full range of values that have been exploited.

CONTRAST AT EDGES:
Most of the wall silhouette is darker than the sky. The latter becomes the apparent light source.

COLOR TEMPERATURE CHANGE:
Sunlight is warm, bright yellow. Shadow is cool, dull purple.

ACCENTS vs. HIGHLIGHTS:
Within a very small distance, values reach extremes. Such contrasts excite the eye, suggesting light.

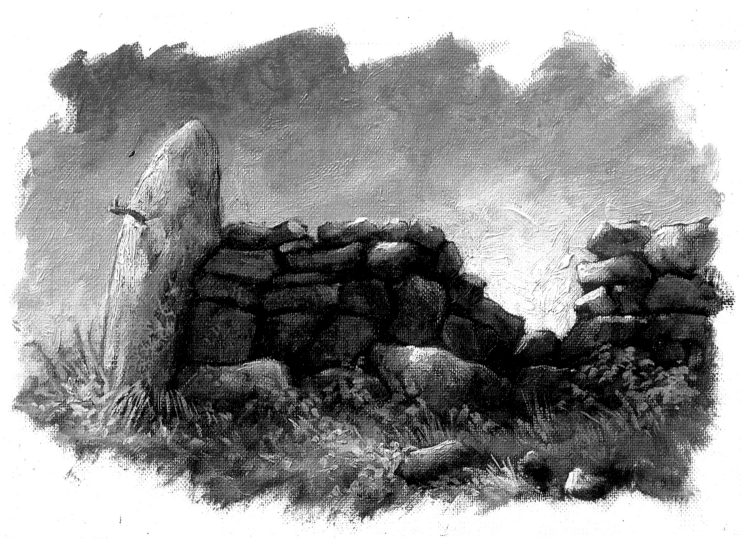

This study in oil of a broken stone wall neatly captures the essence of sunlight and shadow. The oil paint layers are built gradually, from dark to light, so that as the color lightens it also increases in the physical depth of its texture. Paint that physically sticks out from the surface will catch light so that an impasto light is lighter than one that lies flat to the painting. This characteristic can be seen around the brightly lit edge of the upright stone and in the sky through the broken hole in the wall. Glazes of color allow these areas, which are mainly white paint, to stay bright. By far the most controlled glazes are those achieved with oil paint. The color does not change at all as it dries, so what you see is what you get. The physical presence of oil texture and the contrasts attainable put oil painting out at the forefront when it comes to the rendition of sunlight and shadow.

Watercolors

COLOR & COLOR MIXES USED

1. YELLOWS

Lemon yellow (Yg) and Cadmium yellow (Yo) were both used unmixed in pure form directly from the tube, but diluted. Yellow ochre can be brought as a tube color or mixed by adding a little purple to one of the other yellows.

2. PURPLES

These can be used directly from the tube, such as Cobalt Violet, or mixed from any variety of reds and blues to give a range of bright and dull colors.

3. DULL MIXES

Dull mixes toward gray are created as the complementary colors overlap one another in layers. Lemon yellow + purple red (top). Cadmium yellow +purple blue (bottom).

4. COMPLEMENTARIES

The same colors shown on the color circle, exact opposites, are true complementaries and thus capable of reducing each other's intensity (chroma).

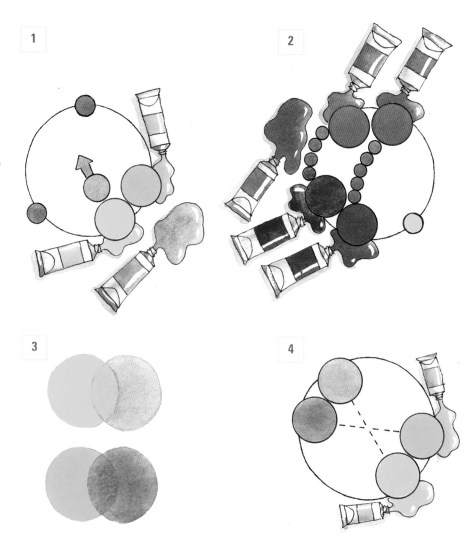

Our sun is yellow, and thus when our eye picks out pure yellows or yellow color mixes, our brain register these as sunlight. The Impressionist painters were greatly influenced in their color mixes by contemporary scientific research, which alluded to the fact that colors complementary or exactly opposite to a light source were to be found in shadows. By bringing the two color elements together, yellow sunlight and purple shadow, we can create contrasts that really evoke light. In this watercolor rendition, the color mixes employed are various mixes of yellow or purple. Where they overlap in layers, they dull each other down toward gray. Soft-edged areas are painted wet-on-wet, hard areas as wet-on-dry. Masking fluid was used in the sky and as highlights to the figure and dog. Wax resist is used on the ground.

Acrylics

ORANGE AND BLUES

Draw composition in using blue and deep orange sketching pastels. Ground is prepainted plywood surface.

Create impasto textures by boldly brushing in a mix (70/30) of household filler and PVA glue. Pastel color bleeds through.

Once dry, overpaint using limited palette of household acrylic emulsion paints (blue-purple, yellow-orange, red-orange). Paint successive layers of fluid washes to create soft colored grays.

Use smaller nylon round brushes as you move to detail. Add white for opacity and highlights and some Artists' Quality Acrylics for color strength.

Painting the space and light under these wonderful Victorian viaducts and bridges had been an ambition of mine for some time. The space is not unlike the interior of a vast cathedral and certainly inspires a feeling of awe as it rises before you. The painting is cathedral like in size - being something in the region of 3ft (90cm) in height and 4ft (120cm) in width. The approach is broad and structured, using standard acrylic household paints applied with large brushes. What a challenge to capture the cool blues of the shadow and the vibrant orange of the shafts of sunlight as they touch the water or illuminate an architectural detail. The more orange the light becomes, the more blue we find in the complementary shadows, and this blue can be quite intense. Finally, we can dispel the myth that shadows have to be dull and gray, for this painting is one of shadows and demonstrates that cool colors can be rich and resonant. Put your black and gray to one side. To fully exploit the possibilities inherent in sunlight and shadow, use complementaries. Mixed, overlaid, or placed next to each other, they will provide all the subtleties of colored gray that you require.

Soft Pastels
WARM TO COOL: LIGHT TO DARK

In this study we do not travel all the way across the color circle to find complementary colors. Instead, we use a pure blue and an orange that is mixed with blue. The latter results in a brown. Pastels are less easy to mix than paint to create strong colors. The answer is to use the brown pastel itself.

The pure whites are the color of the paper, revealed by erasing blue pastel from the surface.

Further values of blue are added along with brown. All mixing, or juxtaposition of the blue and brown pigments on the surface will result in a graying or dulling effect, as the two pigments further neutralize each other.

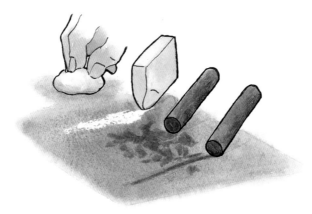

By scraping pigment from a mid value blue pastel and then rubbing into the surface with a cotton wool ball, a flat rectangle of the color was created. Having covered the white paper it can be rediscovered by erasing with a kneadable putty eraser. All the whites were created in this way, sharp edges being achieved through paper masking. Mid-toned blues and even darker browns were drawn on to give the picture its darker tonal accents. The reversal of the normal pastel layering (dark to light) works effectively in this image, the figure and dogs carry the darkest blues, which are added last. This successfully focuses one's attention on them, despite the busy detail of the background. Note how the red umbrella, the only other color apart from the blues and browns, stands out, even though it is far from intense. Also note how close the values of the background actually are and how it is the differences in their color temperatures that provides definition.

Mixed Media

WATERCOLORS (OR ACRYLICS) AND PASTELS

A white ceramic outdoor lantern on a white pillar gleams under a Spanish sun. This evocative subject transports us to the Mediterranean, its warmth, its heat, and — most especially — its light. The simplicity of the subject demands a direct approach, and there is no better one than using the mixed media technique of pastel painted over watercolors. For all its drama, there are no expensive materials needed for this study, which uses a set of cheap and cheerful sketching pastels. Though these are somewhat lacking in pigment, offering only a gentle range of colors, this can be compensated for in the use of a denser underpainting provided by paints. Pastels always require a surface that has a tooth, which provides a physical texture to which the pastel pigment can cling. Paint, especially acrylics, can provide the tooth if it is built up as impasto layers. Here, however, the ground is prepared using thin, dark washes of watercolor, and so a piece of stretched pastel paper is used to provide the tooth. Choose a mid value color tinted paper, which gives a head start in providing contrasts for the light sketching pastels. Note in the final stage how the paper texture is regular, not unlike a canvas texture. You may, or may not, like this particular pattern; if not, choose a paper to meet your taste. This study will bring into effect all the contrasts we have been examining. There will be strong contrasts of value and of color temperature. Layering of color will play its part so that the final surface lights can glow against the powerful darks beneath.

MATERIALS

Brush Pen

Set of 6 Primary Watercolor Paints

Round Watercolor Brush

Set of Sketching Pastels

Colored Pastel Paper

Step 1: Sketching Out Composition

It is essential to stretch the pastel paper for this exercise. Generally, pastel paper is quite thin and will, therefore, warp quite violently when fluid color is applied. A mid-value purple gray color was chosen, being complementary to the final yellow-whites of the sunlight to come. Draw out the image in 2B pencil but don't get involved with the details of the foliage, as patterns here can be more swiftly suggested with the ink line and color to follow. Spend more time on the lamp and its symmetrical structure. Once the ink line is begun, which cannot be erased, you will want to keep changes here to a minimum.

Step 2: Reinforcing Main Masses

The second stage of the drawing is in a way optional. Here it is completed in brush pen, and as you can see, can be strong while at the same time loose. You may decide to move directly from pencil to paint. The ink line is simply more permanent in that it will not be immediately swamped by the pigment. Hence, it remains as a guide much further into the pastel painting. Most of it will eventually be covered by the pastel, so don't worry about its current strength, especially if your hand slips and you make a mistake.

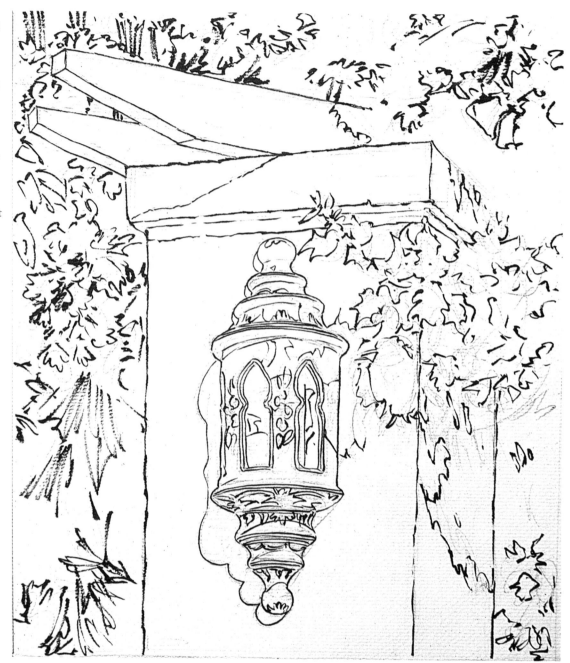

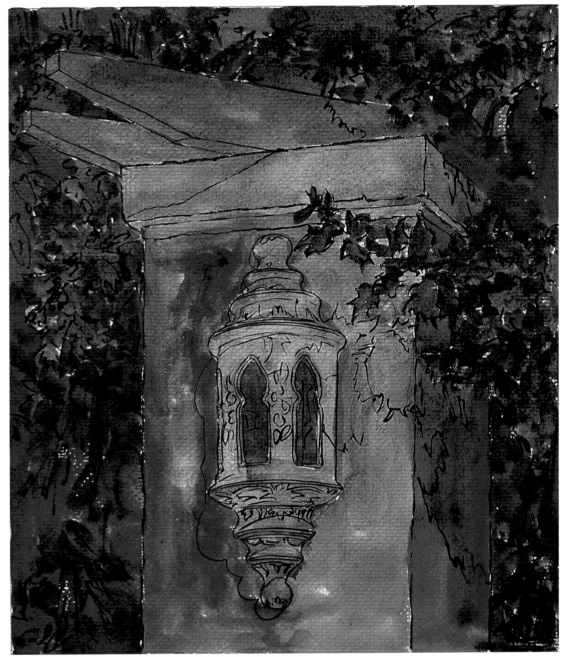

Step 3: Paint Washes: Blocking in Main Masses

This stage again provides a choice in that it is completed in watercolors, but you could easily use thin washes of transparent acrylics with no added white. Either way, the paint will make the surface more receptive to the pastel that follows. Make the washes as dark as you can and change the color mixes as you move across large areas to add variety. A large brush is invaluable for this to effect swift coverage, as you want to get the underpainting on without giving yourself time to worry or fuss. After all, a lot of this is still going to be covered by pastel. Note how only tiny bits of the original colored paper show through and how they almost look white against the dark washes that have been applied.

Step 4: Pastels First Layer

Now you can see the benefit of all of the preceding dark underpainting. The pastel colors, even in the first layer, sparkle against the ground. Paper texture also creates instant impact. Remember that if you do not like this particular texture it is up to you to select a different paper at the start. Varying pressure and direction of the pastel piece describes the light and suggest structure (e.g. crimson flowers top right). If any pastel strokes go beyond their boundaries, erase them with a kneadable putty eraser or more sharply with a scalpel or erasing knife. Note that the areas to be white are either painted yellow (for strong sunlight) or purple (for more gently lit whites).

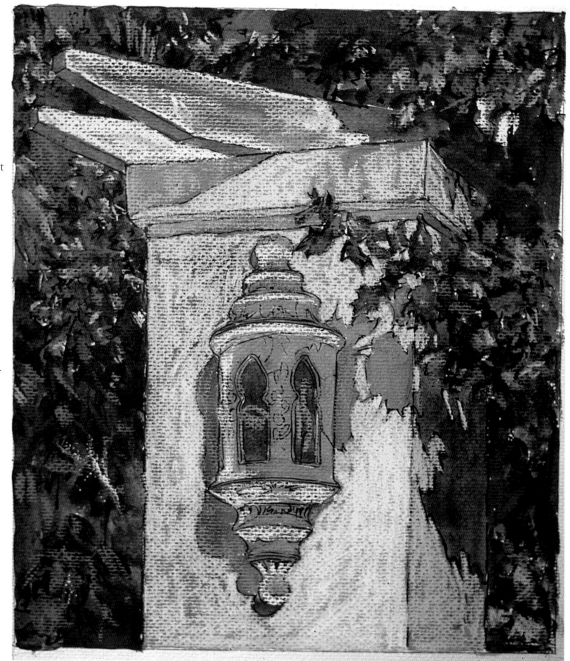

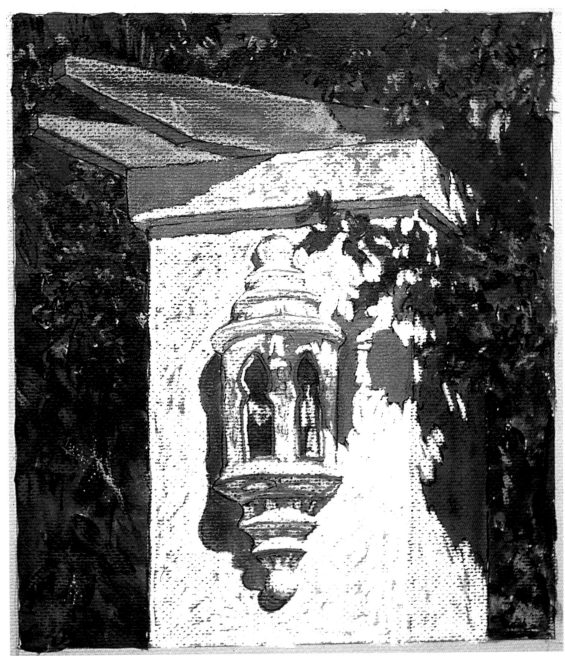

Step 5: Pastels Second Layer

The whites now become a stunning color against the dark foliage that surround them. Both white surfaces are rendered with the same pastel, but each responds to the color beneath, looking either yellow or purple. Using the point of the pastel, rather than its edge, you can really apply some pressure. Strong contrast is desirable for highlights. Often, pressure is needed to adhere the pastel to previous layers. Carefully draw the pastel right up to edges so that the ink line, so important thus far, is now minimized. The pattern to the lamp is the last detail to be applied. Don't be too fussy, or you could lose the accents (darks) that are so important to effect light.

97

MATERIALS

2B Pencil

Indian Ink (waterproof)

Colored Inks

Chinagraph

Artists' Quality Soft
Pastels

Kneadable Putty Eraser

Paper Wiper

Masking Fluid

Acrylic Paints

Gouache Paints

Oil Paints

Round Watercolor
Brushes
(Large to Small Sizes)

No. 3 Nylon Rigger
Brush

Round Brushes for
Acrylic Painting

Round Brushes for Oil
Painting

Oil Painting Thinners

Oil Painting Mediums

Watercolor Paper

Tinted Pastel Paper

Canvas Board

COMPOSITIONS

Introduction

By this point you will see an improvement in the confidence with which you handle light and shade and should be ready to tackle something a little more finished.

Through following the monotone exercise using pencils and watercolors, you will come to realize the potential for exploring this avenue using other media. Many of these, such as pencil, graphite, and charcoal, are dry and might be thought to lie within the stable of drawing. Watercolors, too, can be rendered in just one color, but there is still another — one of the best — wet mediums for monotone, which is ink.

In some ways ink is slightly richer than watercolors in that it has very strong staining powers. When using inks, this must be taken into account, along with the fact that some inks are waterproof and others are not. Both can be used, but at different times, if washes of color are to be laid across them.

The technique employed in the example produced with inks has a long history and some differing approaches. The principle is to mimic aerial perspective in a line and wash image. Using only one color, the color value of the green-gray wash is changed to

suggest distance. To bolster the effect, the line itself is made to diminish in strength. By drawing the line with a Rigger brush, the ink solution can be controlled to do this.

While this example is produced purely in green-gray, you may prefer to render it in the more neutral tones of Indian ink. Establish the various values for light and shade and add color through final washes of either watercolor or ink.

The second exercise is a form of line and wash; however, the color is an opaque Gouache paint. Sometime referred to as "body color," in that it has body (density) that covers and does so quite solidly where necessary. Using this alongside a Chinagraph (wax crayon) line, which repels the water-based paint, is a form of line and wash. Once the paint is used heavily, however, it will eventually cover the line, and this takes us from the realms of line and wash into the realm of pure painting, leaving drawing behind.

Working with pastels is often referred to as "pastel painting," and in following the third exercise you will soon discover why. The build up of layers is very similar to the manner in which an oil painting can be

rendered. The end result of this still life bears a resemblance to an oil painting, and as you work other similarities will strike you, not least that it feels like a painted surface. The layers of pastel create a "fluid" surface, which gives the sensory illusion that the surface is "wet" as the pastel skims across.

The final two compositions deal with the heavyweights in painting: acrylics and oils. Here you can play with depth and sunlight and discover more about what these two dramatic media have to offer.

Line & Tone Shading(Mono)

INKS

[A] Areas masked out with masking fluid before painting starts.

[B] Line diminishes in strength into distance with the addition of water to the ink.

[C] Rigger line dragged sideways.

[D] Rigger line pulled in direction of line.

[E] Graded color washes, applied wet-on-wet in restricted areas.

[F] Darkest value of ink scuffed softly to suggest fine branches.

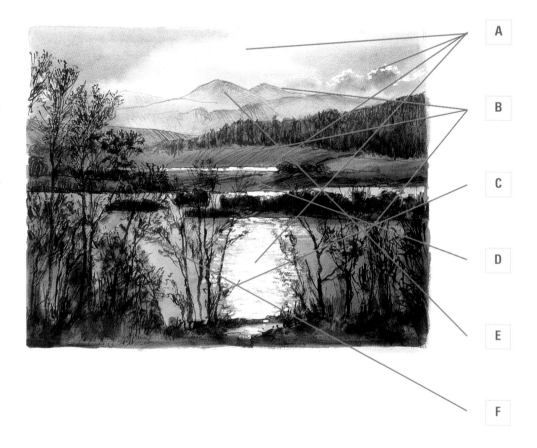

MATERIALS

Indian Ink (waterproof)

Colored Inks

No. 3 Nylon Rigger Brush

Round Nylon Watercolor Brush

Masking Fluid

Watercolor Paper

The whole composition is rendered using only one mix of dull green ink and shows just how much can be achieved before there is any need to introduce color. Premix a dark colored gray ink, consisting of green, some warm yellow, and black Indian ink. The Indian ink used here was waterproof, but the green and yellow proved less so, as they floated out of the dry mix when rewetted. Although unexpected, this proved beneficial in enhancing the atmospheric effect, as it added luminosity.

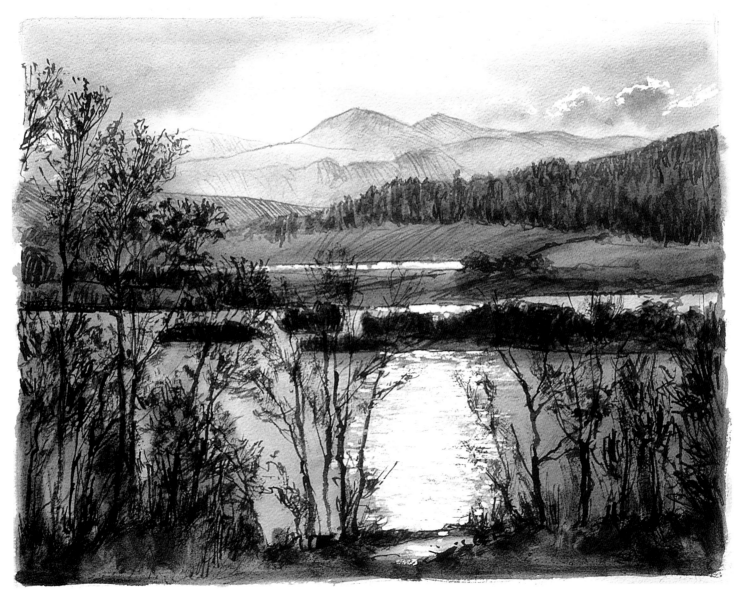

You must be prepared to work with unexpected effects such as this, especially when using ink — as it reacts quite differently from paints when mixed and diluted. Being a stain rather than pigment, ink rapidly sinks into the paper fibers and is thus difficult to remove. This can be done by scratching the ink off the surface, but it does take the paper with it.

Use the Rigger brush to apply the linework vigorously, but keep it loose. Don't worry too much if any of the line goes slightly awry; just work it in with other lines overlaid or placed nearby so that it disappears into a net of fine strokes.

Line & Tone Shading(Color)

CHINAGRAPH & GOUACHE

[A] Dark undercolors bleed through lighter top layer.

[B] Blue reflected light.

[C] Warm green as light passes through leaves.

[D] White added to mix for lightness and extra opacity — color washes.

[E] Stiffer paint mixes as white is progressively added. Final highlight is white without color.

[F] Apply color as a stroke; then leave to dry. Don't overwork, or colors beneath will soften and bleed through.

MATERIALS

Chinagraph (Wax Pencil)

Gouache Paints

Round Watercolor Brushes

(Large to Small Sizes)

Tinted Pastel Paper

Gouache is an opaque watercolor whose slightly cheaper cousin is poster paint, something that most of us have used in school. It is also referred to as "Designers Gouache," which implies that it is quite a sophisticated medium. When used at a creamy consistency, gouache creates a smooth, almost flawless, flat color. The staining power of its pigment is such that it can bleed through a subsequently painted layer. In this flower study it is used more in the manner of watercolor paint, and we weave the natural bleed into the technique.

Chinagraph is a waxy pencil, and as such will resist water-based paints. With fluid transparent watercolors, it remains visible all the way through the painting process. However, when used in conjunction with gouache the effect is slightly different. At first it does resist the gouache, especially as the first layers are applied with lots of water in the mix. Once the opacity and stiffness of the paint mix is increased for subsequent layers, it will succumb to the paint. It does last long enough through early layers to guide the painting, but in the end, although

still present, it is far removed from the dominant role it plays with transparent watercolor. The composition is established using the Chinagraph, with structure and flow of the elements being paid particular attention to so that it works in it's own right within the finished piece.

Tinted paper plays a strong role against the gouache. From the first washes the middle values of the paper work well against the lighter values of gouache. Even white paint works as a color in its own right against this tinted ground.

Build paint swiftly throughout the painting, working wet-on-dry and dark to light and gradually adding more white with stiffer paint mixes. Start with large brushes to lay the greater areas of wash in the early layers, progressively working down to smaller sizes.

Creating Volume

ARTIST'S SOFT PASTELS

[A] Close juxtaposition of values as light is distorted by the glass contours.

[B] Soft blended areas have no focus and thus appear to drop back in depth.

[C] Sharp edges create focus and stand forward in depth.

[D] Greens of the background seen through the glass.

[E] Sharp highlights from unseen light source applied with heavy pressure and pastel point.

MATERIALS

Artist's Quality Soft Pastels

Tinted Pastel Paper

The rendering of transparent objects such as glass depends on distorting background colors as they pass through the objects. Light and highlights can be placed or layered over these distortions. With the ability to build it up in layers, soft pastel is a perfect medium in which to tackle such a subject. Working on pastel paper not only provides a good tooth, essential for the multilayering involved, but also a base color. As you begin with the dark underpainting, it does not look quite so stark against the colored ground, and certainly the lighter values of pastel shine out against it. There is no need to completely cover the paper either, as small areas that remain play their part in the color range of the image as a whole.

When beginning this piece, look at the whole with the eye of an artist; look beneath the surface. This is not easy at first, for our instincts tell us that our eyes should move from highlight to highlight, assessing the quality of the surfaces. You must imagine that all of the highlights have

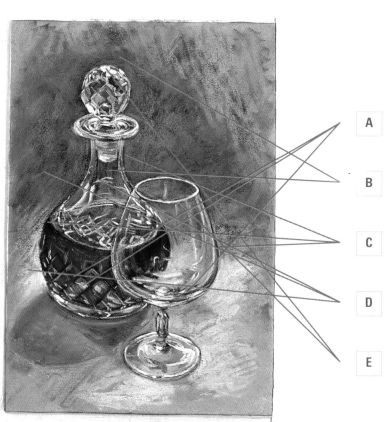

A
B
C
D
E

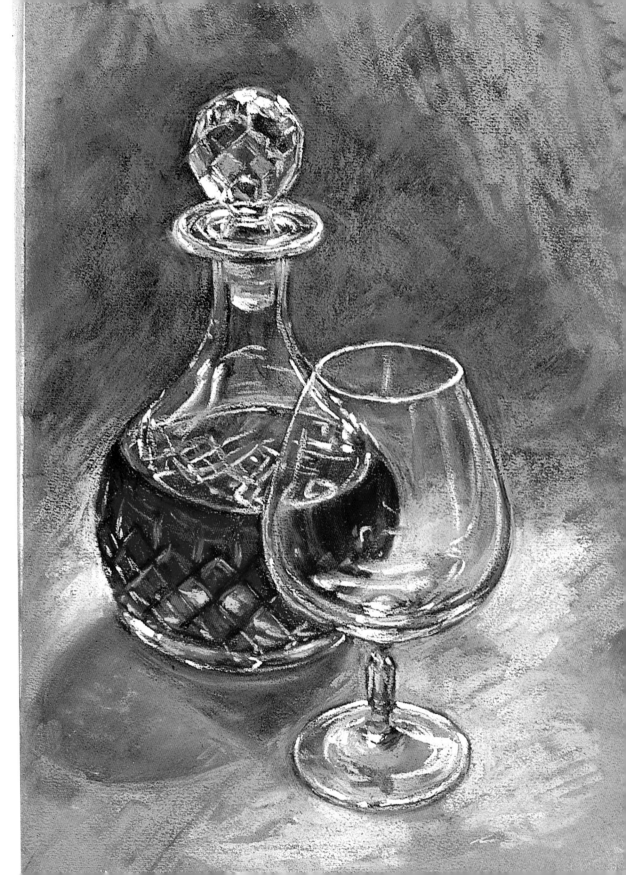

disappeared. What area you left with? At first your brain will tell you, nothing. Look at the brandy glass more carefully. Beneath the highlights there are soft gradations of the background green; study the soft light and shade within. Your first task is to render these soft undertones. Do this throughout the composition, including the soft browns of the brandy itself. You will be tempted to start on a highlight. Resist this for as long as you can.

Behind each highlight is a light. A softer, slightly darker color but still lighter than the colors all around. This is most evident in the brandy glass and the neck of the decanter. Apply these throughout the image, avoiding the placement of highlights themselves. Your patience will ultimately be rewarded when finally applying the highlights, for the glass will spring to life.

Creating Depth

ACRYLIC & DECOLLAGE

[A] Transparent fluid paint floods the scratched and cut surface, creating soft, dark accents.

[B] The strongest contrasts within the composition are between highlight and accent here. They pull the steps forward in space.

[C] The opaque colors begin as cool shadows over the warm underpainting.

[D] Slowly, more and more white enters the mix, and the textures slowly emerge from the shadows into sunlight.

[E] Final sunlit highlights are yellow-white.

[F] Note the complementary contrast of the red and how it really stands out from the green all around it. The increased intensity causes the flowers to be a focal point within the painting.

[G] Scuffing the opaque colors increases texture.

MATERIALS

Acrylic Paints

Acrylic Gloss Medium (for glue and in transparent paint mixes)

Round Brushes for Acrylic Painting

Stretched Watercolor Paper

Several Layers of Glued Pastel Paper

These sunlit steps in an Italian village provide strong contrasts of light and shade, achieved through the interplay of opaque and transparent colors. To fully exploit the paint, a unique surface is developed by means of decollage. While collage involves the build up of the surface through the adhesion of paper layers, decollage is the exact opposite. Several layers of paper are glued over each other, and once thoroughly dried, through the ground is cut, gouged or scratched through, leaving a shallow, yet three-dimensional surface. Damaged paper can absorb more color, so scratched or torn edges become dark accents with the application of the first warm layers of fluid acrylic paint mixes (color plus acrylic gloss medium).

To add sunlight over this, make the colors progressively more opaque with the addition of white. The addition of blue or yellow to these same mixes gives you the option of pure yellow sunlight, or cool blue reflected light.

Inevitably, because acrylic paint dries darker and slightly more transparent, several layers are often necessary before the desired result is obtained. As you move toward these light textures, the structured surface fulfils another function. It facilitates scuffing and scumbling, which catches its raised texture — just as real sunlight would.
Having this underlying, strong, built-up structure has a psychological effect as well, for you can apply the color with a sense of freedom, knowing the drawing has already been embodied in the texture of the surface. A particularly exciting aspect to this type of work is in the hanging of the framed result, for the lighting can accentuate the inherent structure of the work if well placed.

Sunlight & Shadow

OIL PAINTS

[A] Graded color in the sky starts as a line of color along the top. Progressive lines beneath contain more and more Titanium white.

[B] Distant blue-gray details overpainted with tints (tints = color plus white plus medium).

[C] Middle value colors on both accents and highlights throw these trees into the middle distance.

[D] The most powerful contrasts between dark accent and highlight are in the foreground.

[E] Rich coloration created by glazing over impasto color [glaze = color plus medium].

[F] Highlights scuffed over glazes — the unique sparkle of oil painting contrasts at their most powerful.

[G] Rich colors in the shadows — warm color layers over cool and vice versa.

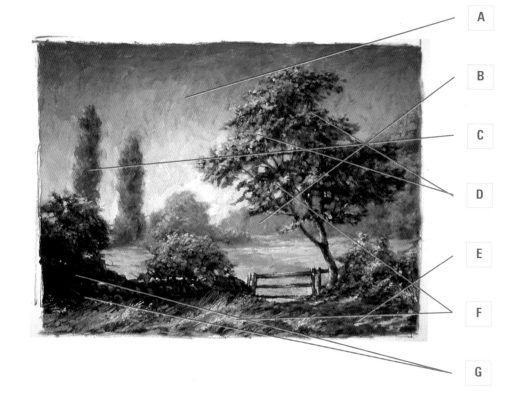

MATERIALS

Oil Paints

Oil Painting Thinners

Oil Painting Mediums

Round Brushes for Oil Painting

Canvas Board

This imaginary landscape has been put together to feature as many of the effects of depth and sunlight as possible, which can be achieved through the traditional layering techniques of an oil painting. The painting is started with a dark underpainting, applied fluidly with the aid of thinners. This effectively establishes the accent colors at the outset. Over this the impasto layer (tube consistency) is applied to lay the mid value colors, which also defines the textures and structure of the surface. Tints and glazes, made fluid by the addition of oil mediums, are introduced to the dry impasto surface, changing the nature of both texture and color. Finally, highlights are scuffed on to the prominent or exposed high points of the impasto.

This layering from dark to light, lean (little oil medium) to fat (added oil medium), helps to achieve one of the largest ranges of contrasts available to the artist. The more extreme the variables, the more the possibilities extend for suggesting light. The physical attributes

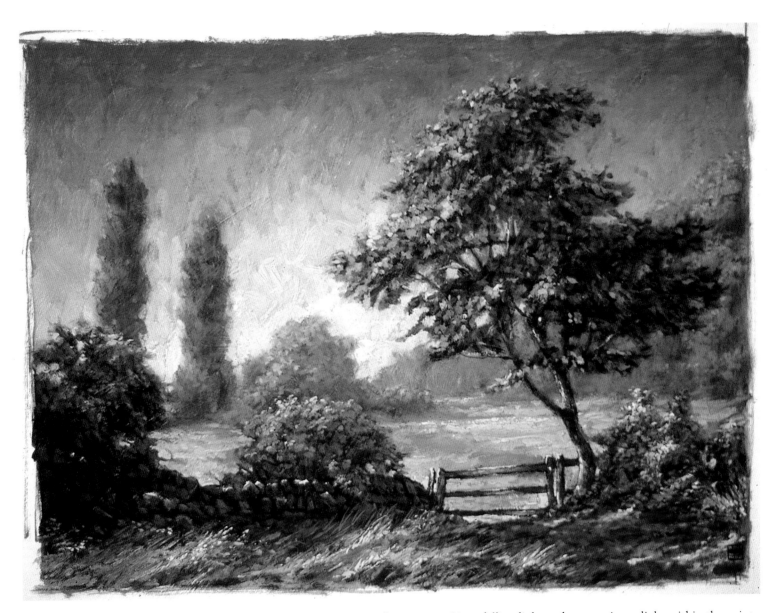

of the finished surface, with its protruding lights and highlights, will capture ambient falling light and suggest inner light within the paint as it is reflected back to the observer.

It is this traditional method of layering oils and the use of glazing and tinting to enrich and enliven the surface that sets oil painting apart. I encourage all would-be and established painters to understand and utilize it as part of their everyday painting repertoire. Without it, you will miss much of the sheer drama and inherent beauty of oil paints.

ART TECHNIQUES FROM PENCIL TO PAINT
by *Paul Taggart*

Based on techniques, this series of books takes readers through the natural
progression from drawing to painting and shows the common
effects that can be achieved by each of the principal media, using a variety of techniques.

Each book features six main sections comprising of exercises and tutorials
worked in the principle media. Supportive sections on materials and tips,
plus color mixing, complete these workshop-style books.

Book 1
LINE TO STROKE

Book 2
LINE & WASH

Book 3
TEXTURES & EFFECTS

Book 4
LIGHT & SHADE

Book 5
SKETCH & COLOR

Book 6
BRUSH & COLOR

ACKNOWLEDGMENTS

There are key people in my life whom have inspired me over many, many years,
and to them I extend my undiminishing heartfelt thanks.
Others have more recently entered the realms of those in whom I place my trust and I am privileged to know them.
Staunch collectors of my work have never wavered in their support,
which has enabled me to continue to produce a body of collectable work,
along with the tutorial material that is needed for books such as this series.
I will never cease to tutor, for the joy of sharing my passion for painting is irreplaceable
and nothing gives me greater pleasure than to know that others are also benefiting from the experience.

INFORMATION

Art Workshop With Paul Taggart is the banner under which Paul Taggart offers a variety of learning aids,
projects and events. In addition to books, videos and home-study packs, these include painting courses,
painting days out, painting house parties and painting holidays.

ART WORKSHOP WITH PAUL

Log on to the artworkshopwithpaul.com website for on-site tutorials
and a host of other information relating to working with
watercolors, oils, acrylics, pastels, drawing and other media.
http://www.artworkshopwithpaul.com

To receive further and future information write to:-
Art Workshop With Paul Taggart / PTP
Promark
Studio 282, 24 Station Square
Inverness, Scotland
IV1 1LD
E-Mail : mail@artworkshopwithpaul.com

ART WORKSHOP WITH PAUL TAGGART
Tuition & Guidance for the Artist in Everyone